MW00608268

IMAGES
of America

NEW RIVER
GORGE

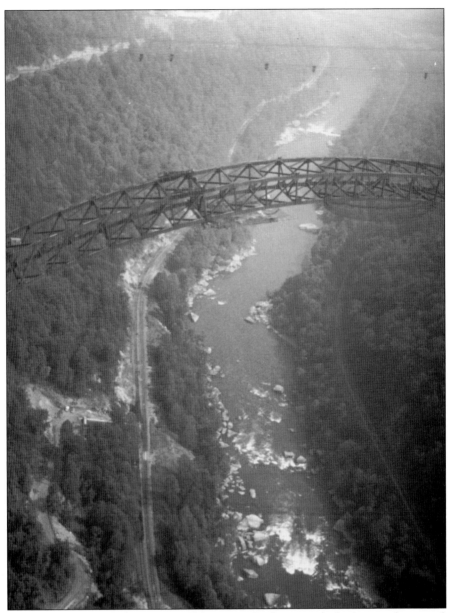

The now-freestanding arch on the New River Gorge Bridge casts its shadow on the gorge below. A unique truss design allows the top and bottom chords of the arch to share the compressive loads. Bridge designer Michael Baker Jr. and his team logged 31,200 hours—the equivalent of one man working 40 hours per week for 15 years—designing the bridge. (Photograph by David Bowen, courtesy West Virginia Division of Highways.)

ON THE COVER: Hayes Drug Store, on Main Street in Oak Hill, West Virginia, was a popular meeting place for residents in the late 1910s and early 1920s, around the time of this photograph. The little girl in the stylish hat on the running board of the Model T is Mary Goode (now deceased). She is visiting her uncle Wayne Hayes, proprietor of W. R. Hayes and Company, who is sitting on the far right at the end of the porch. (Courtesy Tim Richardson.)

IMAGES
of America

NEW RIVER GORGE

J. Scott Legg and the Fayette
County Chamber of Commerce

ARCADIA
PUBLISHING

Published by Arcadia Publishing
Charleston SC, Chicago IL, Portsmouth NH, San Francisco CA

Printed in the United States of America

Library of Congress Control Number: 2010921014

For all general information contact Arcadia Publishing at:
Telephone 843-853-2070
Fax 843-853-0044
E-mail sales@arcadiapublishing.com
For customer service and orders:
Toll-Free 1-888-313-2665

Visit us on the Internet at www.arcadiapublishing.com

*To Gina, whose encouragement, support, and
caption writing made all the difference*

CONTENTS

ACKNOWLEDGMENTS

Since William O. Trevey and Rufus "Red" Ribble started photographing the New River Gorge over 100 years ago, local historians have collected and reproduced their photographs. While it is impossible to name or thank all of those people, I would like to thank George and Melody Bragg for publishing a large number of those images and kindling my interest in the area.

I would also like to thank Tim Richardson for providing his collection of photographs of Oak Hill, West Virginia, and patiently describing each photograph and its location.

I appreciate the help and encouragement of the staff at the New River Gorge National River, some of who are new acquaintances and many who are old friends from my years as a park ranger.

Sharon Cruikshank and Cindy Dragan, of the Fayette County Chamber of Commerce and New River Convention and Visitors Bureau in Oak Hill, West Virginia, were instrumental in helping to complete this project. And without their support and enthusiasm, I would not have gotten underway.

And thanks to Amy Perryman, my Arcadia editor, without whose excellent guidance and sense of humor, this work would have just remained a stack of photographs on my desk.

Unless otherwise noted, all images appear courtesy of the National Park Service (NPS), New River Gorge National River, Glen Jean, West Virginia. The West Virginia Division of Highways (WVDOH) and U.S. Geological Survey (USGS) also provided photographs.

INTRODUCTION

Since the country's birth, George Washington and other prominent Virginians had sought to unlock the wealth of Virginia's western territories by building a commercial link through the New River Gorge. Unlike other waterways, though, the New River fell through a series of rapids and waterfalls that could not be tamed by canal technologies of the day; the final link would not be finished until the railroad age.

It fell to Collis P. Huntington, fresh off his success in the development of the transcontinental railroad, to invest his insight and financial ability and finish the connection. The completion of the Chesapeake and Ohio Railway (C&O) mainline in 1873 marked the realization of Washington's dream and the beginning of economic wealth and prosperity for the New River Gorge.

It was also in 1873 that Capt. W. D. Thurmond acquired 73 acres along the New River. Thurmond was a returning Confederate soldier who had led a group known as Thurmond's Rangers. Returning to his home after the Civil War, Thurmond found it burned and his land worthless. He worked as a surveyor, and when a farmer offered land in lieu of cash payment, Thurmond chose acreage along the New River. He played a hunch that the land in the New River Gorge across from Dunloup Creek would be a good spot for a town and a railroad trestle. The farmer was glad to oblige, and a deal was struck. Captain Thurmond and his sons operated a ferry on the site until a trestle was built connecting the property to the south side of the gorge. Thurmond wanted to name his new town Arbuckle, but the name was already taken, so the town was named Thurmond, and it soon became the heart of the New River Gorge. Halfway between Gauley Bridge and Hinton, West Virginia, Captain Thurmond's bend along the river was a key spot for steam locomotives needing coal and water for fuel. Thurmond used the money he earned to develop his land. As the railroad prospered, so did the town. By 1889, the C&O had constructed sidings, a passenger and freight depot, a turntable, water towers, and an engine house at Thurmond.

Across the New River, another entrepreneur was developing a very different plan. Thomas McKell built the original railroad trestle connecting Thurmond to his holdings across the New River along Dunloup Creek so that he could ship coal from his mines. By the early 1900s, hundreds of railroad cars of smokeless coal were being hauled through the town everyday from several nearby branch lines. In 1910, Thurmond was the main railroad hub on the C&O, producing more freight tonnage than Cincinnati, Ohio, and Richmond, Virginia, combined.

But freight was not the only key to the town's success. In 1910, seventy-five thousand passengers passed through Thurmond, and at its peak, the town had two hotels, two banks, restaurants, clothing stores, a jewelry store, a movie theater, several dry goods stores, and many business offices. Thurmond continued to thrive through the early decades of the 20th century. With the huge amounts of coal in the region and a prosperous coal baron among its patrons, Thurmond's banks were the richest in the West Virginia. Thurmond was thriving, but it was a dry town. Captain Thurmond was a devout Baptist, and as saloons opened up across the river, he incorporated Thurmond to keep saloons out. He also tried to expand his town's influence across the river to close down the saloons and brothels in the area known as the Ballyhack district.

Thomas McKell owned the land across the river, and he had other plans for his property. In 1901, McKell constructed a 100-room luxury hotel named the Dunglen with a bar and gambling area. The Dunglen took on a life of its own and became one of the best-known hotels in the eastern United States. As the Dunglen and Ballyhack grew in notoriety, Captain Thurmond, seeing the reputation of his town suffer, decided to clean up the area. McKell did not appreciate Thurmond's moralistic attitude limiting his business opportunities and countered Thurmond's actions by extending the boundary of his town, Glen Jean, seven miles up Dunloup Creek and down to and around the Dunglen and Ballyhack. With the saloons now safe in Glen Jean, there was little Thurmond could do.

When Captain Thurmond died in 1909, his town still had its best years ahead. The period from 1910 to 1930 witnessed the Thurmond's greatest growth, and by 1930, it had a population of 450.

With the onset of the Great Depression, several businesses closed, including the National Bank of Thurmond, and two large fires destroyed local businesses. Thurmond was rebuilt, but the decline of the mines and the automobile's success meant that many businesses moved to Oak Hill and Beckley. Arsonists burned the Dunglen Hotel in 1930, and Thurmond's heyday was ending. The American public had begun its love affair with the automobile, and good roads made travel by car easy.

The World War II era brought renewed vigor to the C&O, but by the 1950s, Thurmond began to slide once again. At the end of the war, the C&O, like other railroads, switched from steam to diesel locomotives, and Thurmond lost its purpose. It had been a steam town; its railyard and crews were geared toward the short service intervals of steam locomotives. The switch to diesels made the railyard structures and jobs obsolete. With the coalfields played out and the trains not stopping, the years between 1946 and 1966 were quiet. Thurmond became a sleepy little flag stop on the railroad.

In 1968, another entrepreneur was looking for a place to start his business. Beginning with an army surplus raft, Jon Dragan and his brothers chose Thurmond as the place to open Wildwater Unlimited. The Dragans pioneered whitewater rafting in the eastern United States, and what started as a few hardy souls floating down the river turned into 17 outfitters and an industry that still brings 100,000 people a year to the New River Gorge.

The 1970s also brought the construction of the New River Gorge Bridge and the arrival of the National Park Service. The New River Gorge National River was established on November 10, 1978, to conserve and interpret the area in the New River Gorge and to preserve the New River as a free-flowing stream. In 1995, the park service restored the Thurmond Depot as a seasonal visitor center, keeping the heart of the New River Gorge on the map.

A long time has passed since Captain Thurmond returned home to start fresh after the Civil War, and it has been a generation since three kids with an army surplus raft showed up to tame the New River. From its quiet beginnings to its heyday of steam and coal, Thurmond has a special place in West Virginia history. Today the town and the gorge still hum to the sound of long freight trains and the roar of the river, and Thurmond still holds a record—West Virginia's smallest incorporated town, with a population of seven.

One

EARLY SETTLEMENT

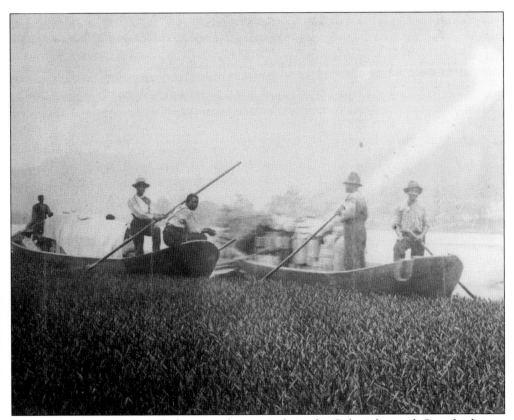

Bateaux were shallow-draft flatboats used extensively in the Colonial period. Specific designs were developed to suit local conditions. Bateaux were meant to maneuver quickly and withstand dangerous river conditions. They hauled supplies to river towns and delivered heavy timbers downstream to waiting lumber mills. The town of Ronceverte, West Virginia, commemorates the logging and bateau industry with an annual outdoor theater, *Riders of the Flood.*

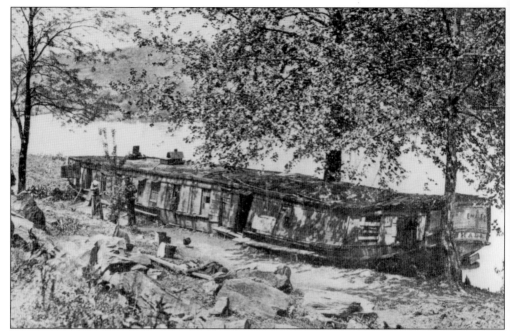

Before being incorporated in the Chesapeake and Ohio Railroad (C&O), the James River and Kanawha Canal was the principal means of river transportation. The packet boat *Marshall* is an example of the transportation used to traverse flat-water stretches of the New River during the 19th century. Once downstream, bateaux and packet boats were broken up for lumber or sold, and their sailors walked home.

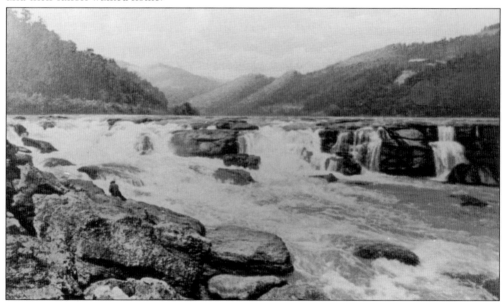

Majestically beautiful Sandstone Falls exemplifies the dangers of travel along the New River. A race, or man-made channel, diverted water to operate Richmond's Mill at the falls, and at low water, bateaux men used it to circumvent the falls. At high water, the falls themselves were navigable. Chief Justice John Marshall traversed the falls in 1812 and suggested that a dam and lock be built to improve navigation.

This drawing depicts the last attack of the Battle of Fayetteville, West Virginia, on May 21, 1863. The battle was the first instance of indirect firing of cannon during the Civil War. Confederate sergeant Milton W. Humphries of Bryan's Battery attempted to dislodge the Union army from its position by firing his howitzers over the intervening forest. A roadside marker commemorates the Confederate battery's location.

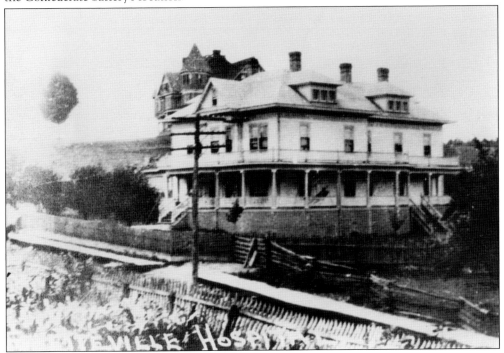

This large white house served as a hospital during the Civil War. The top step of the home's stoop was inscribed with the word *Hospital*, still visible from the sidewalk along West Maple Avenue in Fayetteville. The house on the left is the site of the original Union fort. It is currently the home of Dodd-Payne-Hess Funeral Home. (Courtesy Sharon Cruikshank.)

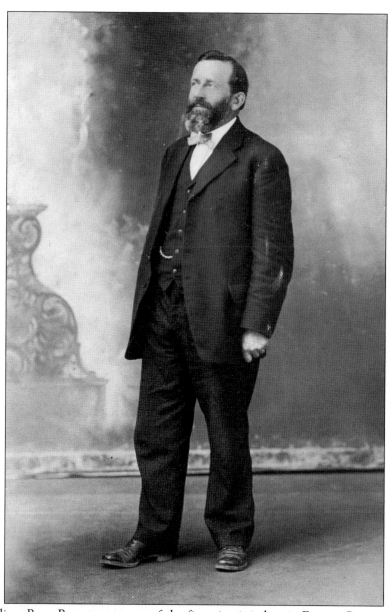

Judge William Ryan Bennett was one of the first circuit judges in Fayette County. The *New York Times* reported on August 20, 1912: "Circuit Judge William R. Bennett to-day handed his resignation to Governor William E. Glasscock. It was accepted. On August 19, 1912, citizens of Fayette County presented a petition to the governor asking him to call an extra session of the legislature to impeach Judge Bennett, charging him with misconduct in office. Judge Bennett, in resigning, says his reason for so doing is that he 'does not care to embarrass the people of his circuit, by a continuation in office of myself while under suspicion.'" Bennett later defended striking coal miners during the 1921 coal wars. Accused of conspiring and dynamiting the coal tipple of the Willis Branch Coal Company at Paint Creek, striking miners were tried under conspiracy or "Redmen's Statute." The men were convicted of causing property damage of $25,000 and destroying 40 coal cars and sentenced to seven years in the Moundsville Penitentiary. Bennett posed for this portrait around 1890. (Courtesy Sharon Cruikshank.)

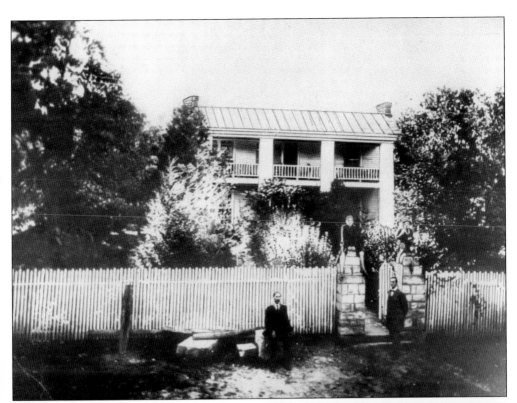

The Bennett home was located on the old Giles, Fayette, and Kanawha Turnpike, west of Fayetteville at Goose Creek. In this early photograph, Judge Bennett sits on the horse-mounting block to the left, while his brother stands at the gate. Two playful boys have climbed atop the gateposts. (Courtesy Sharon Cruikshank.)

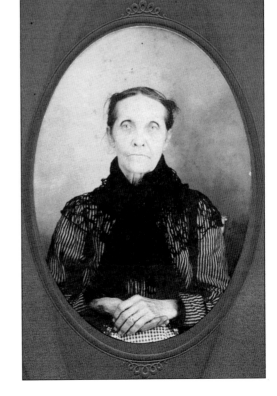

This early portrait shows Judge Bennett's mother-in-law, Luticia Ann Kuhn. Kuhn immigrated to America from Germany and settled along the Kanawha River before moving to up to the plateau area near Fayetteville to live in the Bennett family home. (Courtesy Sharon Cruikshank.)

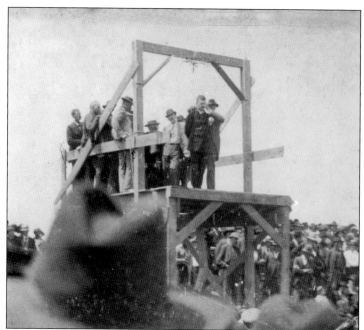

Information from the expense account of Fayette County deputy sheriff J. M. Koontz, dated July 18, 1894, denotes this photograph as the hanging of Wash Adkins. Wash was convicted of killing Isaac Radford at Deepwater on November 11, 1893. Koontz's itemized list noted "in scaffold $1.25, hangman's rope $.60, material for cap $.50, straps $.35 – total $2.70." Adkins's was the last public hanging in Fayette County. (Courtesy Tim Richardson.)

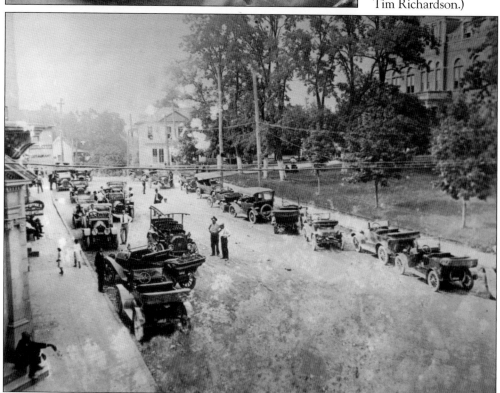

It's a busy day at Fayetteville Court House Square around 1915. The courthouse is in the upper right corner of the photograph. The wrought iron fence that was later moved to the city cemetery still encircles the lawn of the courthouse. The two men in the middle of the street admire a three-seated touring car. (Courtesy Tim Richmond.)

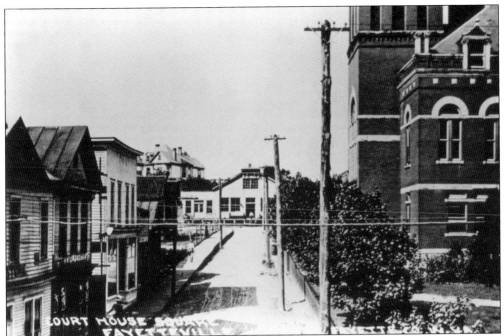

The view up Wiseman Avenue ends at Props Hardware Store. The house belonging to Judge William Bennett's daughter, Thelma Bennett Blume, is visible in the left background with the dominant roofline and several chimneys.

Thelma Bennett married Edward Blume from Fayette, becoming Mrs. E. G. Blume. The Blumes moved into the Bennett family home that still stands today. It was originally located behind Props Hardware. A winter photograph of the home served as the Blume's holiday card one year. (Courtesy Sharon Cruikshank.)

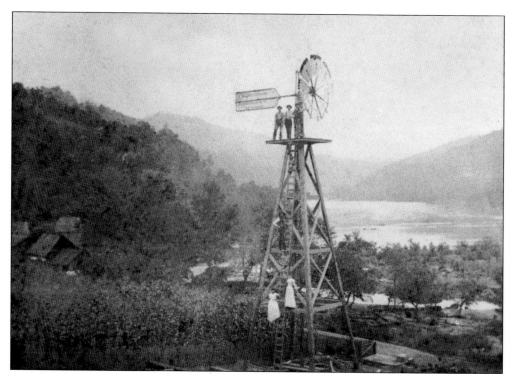

Six adventurous adults climb a windmill on a farm near Hinton, West Virginia, around 1900. A cornfield is on the left, and the New River or Greenbrier River is in the background on the right. Windmills were used to pump water to fields and homes along the New River. Visible at the bottom of the picture is the pumping shaft entering the well.

This *c.* 1900 photograph shows a farm on Bunker Hill near Oak Hill. It is typical of farms atop the plateau region of the New River Gorge. On the right toward the edge of the horizon, churches are visible. (Courtesy Tim Richardson.)

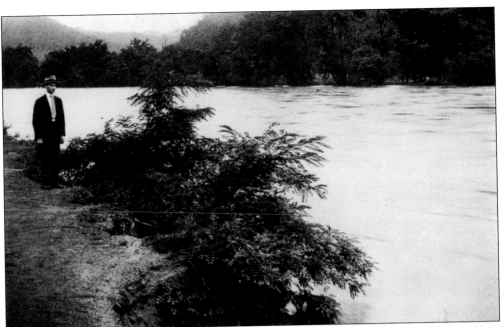

This portion of the river, near Avis, is a broad flat-water section now known as the Upper New. During the flood of 1916, the river rose at a rate of 3 feet per hour. In 1940, another serious flood affected the New River. In 1941, the Army Corps of Engineers began building the Bluestone Dam. Construction was suspended due to World War II but resumed in 1946. The 165-foot-high, 2,048-foot-long dam became operational in 1949.

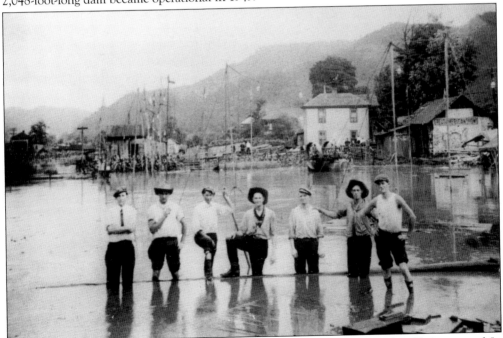

When the 1901 carnival arrived in Avis, a flood was the last thing carnival workers likely expected. In the photograph above, seven carnies wade through the town. The Bluestone River and the Greenbrier River converge with the New River above Hinton, and floods were a frequent occurrence.

Construction superintendent Crockett W. Creger and his crew built many of the New River Gorge's early structures, from mine buildings to spacious homes. Construction in the gorge relied on a large number of skilled stonemasons and carpenters to build the coal mining camps. Although the many wooden structures quickly disappeared, many of the stone constructions are still visible and bear their maker's names and symbols. Large numbers of Italian immigrants moved to southern West Virginia to work as stonemasons and later became coal miners after the towns were constructed. It was also common for the friends of a fallen stonemason to carve his name into the stone as a memorial upon his death.

Two

GAULEY BRIDGE TO HAWKS NEST

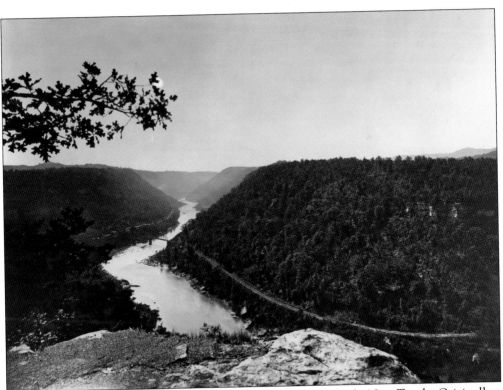

The C&O crosses from "river left" to "river right" across the Hawks Nest Trestle. Originally a single line on one side of the river, the C&O soon found it necessary to lay track on both sides of the gorge from Hawks Nest to Thurmond. This photograph also shows the area before the Hawks Nest Dam created Hawks Nest Lake. (Photograph by J. K. Hillers, courtesy USGS.)

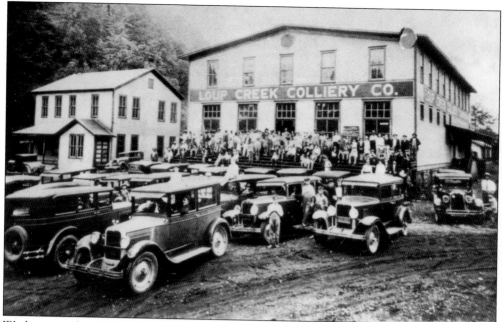

Workers pose for a picture on the steps of the Loup Creek Colliery Company store in Page, West Virginia. The large number of cars of various makes and models indicates the prosperity of the area during the heyday of coal. Proximity to the C&O provided direct access to the latest consumer goods. Before the days of automobiles, traveling salesmen were called "tie-walkers," since they walked the tracks selling goods door-to-door.

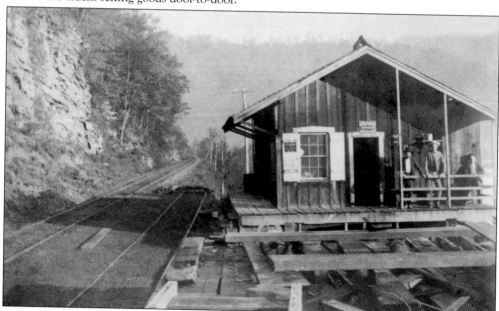

The Adams Express Company, in Gauley, West Virginia, delivered parcels heavier than one pound. The office was located between the railroad tracks and the river, with a siding, or extra set of rails, just to the left of the office. The siding was used to load and unload large parcels and pallets from the train cars onto the large skids on the right. During World War I, Adams Express became part of the American Railway Express Company.

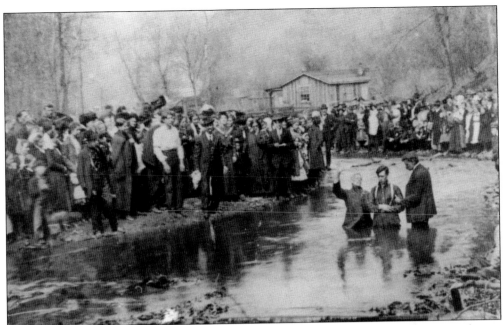

Religion was an integral part of life along the New River. Here a baptismal service is underway near the town of Mammoth, West Virginia. Many denominations in the mountains believed in baptism by submersion and waited for spring to hold services outside in the cold waters. Arthur Hurley is being baptized in the middle of the river. Rachel (with hand on face) and Henry Robinson are in the center of the photograph.

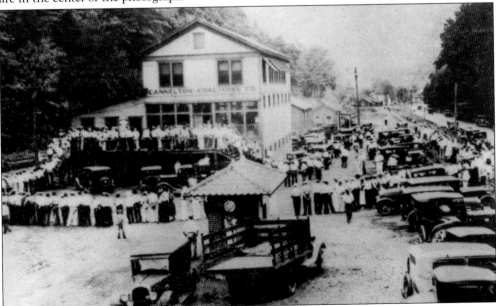

Workers line up outside of the Cannelton Coal and Coke Company store on payday. They were paid in company scrip redeemable only at the company store. Since miners had little currency, they were forced to purchase all goods at the store, which often caused them to live in debt. Each coal company issued its own scrip. An armed man is just to the left of the brick structure in the foreground.

Construction of mines and improving technology quickly made these coal by-product ovens at Hawks Nest Station obsolete by the time USGS photographer J. K. Hillers arrived in the gorge in 1894. Hillers was under contract to the USGS to travel and photograph the United States as part of its geologic studies. (Photograph by J. K. Hillers, courtesy USGS.)

Built during the Great Depression, work within the Hawks Nest Tunnel was dangerous due to the inhalation of silica dust particles. Large numbers of migrant African Americans came to work in the tunnel. After construction ended, Gauley Bridge, West Virginia, became known as the Town of the Living Dead. Estimates state that between 400 to 1,000 men died from silicosis caused by breathing the dust. Many died within one year. (Courtesy Tom Dragan.)

The massive scale of the 32-foot diameter tunnels is visible as an inspector stands in the Hawks Nest diversion shaft. The inspector may have been one of the last people to see the tunnel. It has remained flooded since the gates were opened. Construction of Hawks Nest Dam took place from 1930 to 1933. (Courtesy Tom Dragan.)

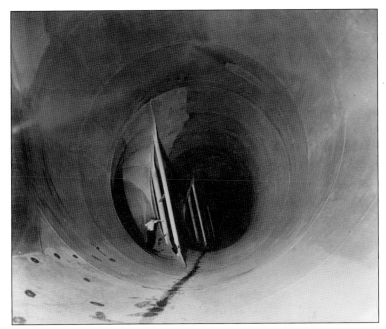

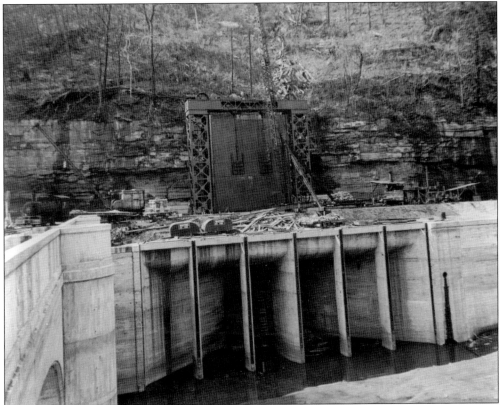

The scale of the exterior of the tunnel's mouth and gate is visible in this photograph, which shows a steam locomotive pulling a crane to the left of the gate. The tunnel falls 162 feet before reaching the hydroelectric generators across the mountain. (Courtesy Tom Dragan.)

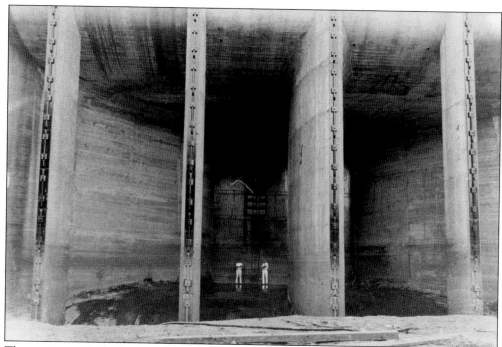

The caption on the back of the photograph reads: "Tunnel for the New-Kanawha Power Company. Tunnel intake without racks and with gates lowered. D. L. Cook, inspector-in-charge and an unknown man." Diversion of the water through the 6-mile-long, 32-foot-diameter tunnel under Gauley Mountain created a section of river now known as "the dries." (Courtesy Tom Dragan.)

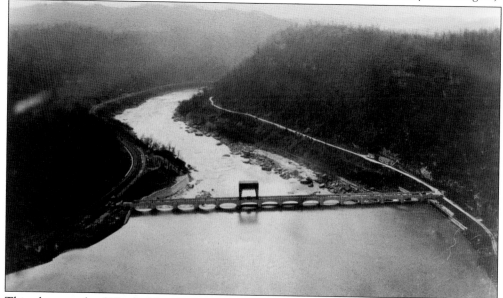

This photograph of Hawks Nest Dam was taken from Hawks Nest Rock on February 1, 1937, with the pool above the dam raised to an elevation of 815 feet. The dam's purpose was to divert water through the Hawk's Nest Tunnel, providing electrical power to a steel mill located on the downstream side of Gauley Mountain. The tunnel would soon become known as one of America's worst industrial accidents. (Courtesy Tom Dragan.)

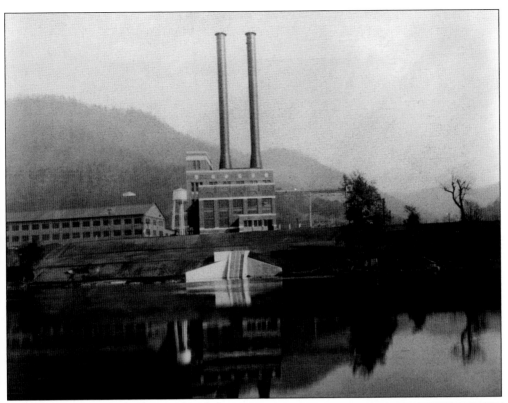

The mountains in the background and the basin below frame the Hawks Nest power plant. Hawks Nest Dam was constructed to generate electricity for a plant downstream at Alloy. Most of the New River was diverted into a tunnel to improve power generation for Union Carbide. Water reenters the river near Gauley Bridge, leaving a section known as the dries in between. (Courtesy Tom Dragan.)

The young girl in the 1930s at Hawks Nest Trestle is Betty Alexander-Martin. Betty lived in Nuttallburg but attended school in Ansted. She later moved to Mount Hope, West Virginia. With the proximity of the railroad and streetcars, students could ride the train to the schools of their choice. The children of wealthy parents would ride as far as Montgomery to attend high school and college.

This view from Hawks Nest overlooks the pool created by Hawks Nest Dam and is one of the most photographed spots in West Virginia. In the 1930s, the Civilian Conservation Corps built the overlook on U.S. Route 60 near Ansted. Route 60 was originally an east-west buffalo trail along the gorge. Native Americans and early settlers used the trail to avoid the rocky gorge.

Three

FAYETTE STATION TO KAYMOOR

At the south end of Fayette Station Bridge, Wolf Creek enters the New River. This picturesque spot has been a favorite location for photographers since the 19th century. The note states this photograph was taken on August 20, 1900. Wolf Creek is a popular trout-fishing stream in spring and still a popular gathering spot on a hot August day.

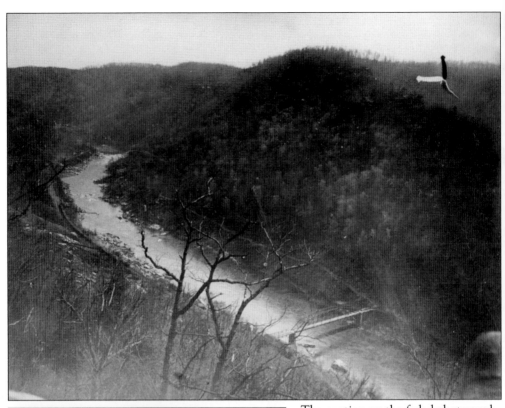

The caption on the faded photograph reads: "From 1000 ft. above New River, WV, 20 Aug. 1900." Built in 1889, the Fayette Station Bridge connected the towns of Fayette and South Fayette across the river. Railroads are visible on both riverbanks, and a train is discernible along the left side of the photograph just left of the jutting tree branches.

Wrench in hand, Bill Bennett, son of William R. Bennett, stands proudly in his World War I uniform and campaign hat as he works on his car in the yard of the family home. It appears that the car's engine is hanging from the frame at his right. (Courtesy Sharon Cruikshank.)

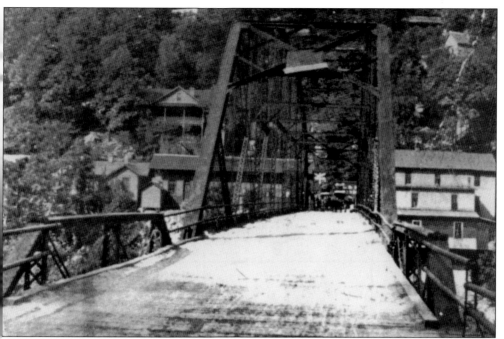

This close-up of the Fayette Station Bridge reveals the wooden decking as well as a crowd gathered at the far end, in the town of Fayette. The Blume Company store is on the right, with a parking garage to the left. Automobile owners who lived further in the gorge could rent space to park their cars in the garage and ride the train home. (Courtesy Sharon Cruikshank.)

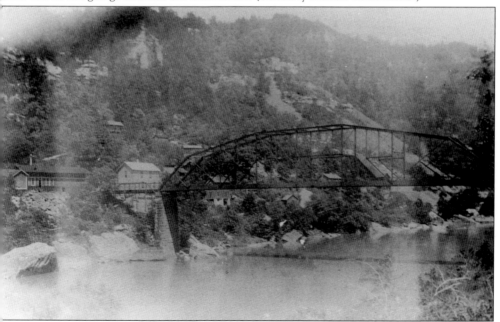

Space was at a premium at the bottom of the gorge, and homes were built on stilts or stepped foundations from the cliff face down to the river. Remaining flat areas were terraced and planted as gardens. The garage to the left of the bridge burned down as the result of three young boys learning to smoke on the gasoline tanks stored in the garage. (Courtesy Sharon Cruikshank.)

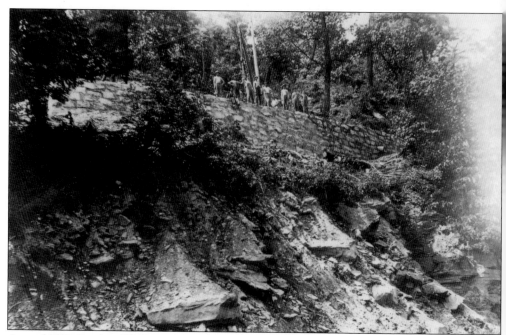

Around 1910, Crockett W. Creger's crew takes a break from constructing a retaining wall on the south side of Fayette Station Road to pose for this photograph. The wall still stands and is visible across the gorge from underneath the New River Gorge Bridge. Whitewater rafters say that the trip up Fayette Station Road after a day on the water is the most exciting and dangerous part of their trip.

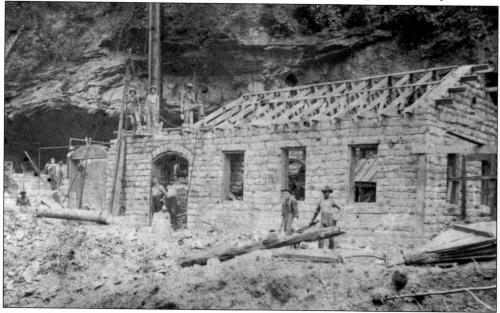

A powerhouse is under construction in Michigan, later renamed Ames, on the north side of the New River. The cut-stone building houses a coal-fired boiler that heated water to generate steam. The steam turned a generator and created electricity for the mine. The powerhouse also provided hot water to neighboring homes, and a short blast from its steam whistle sounded the alarm for coal mining accidents.

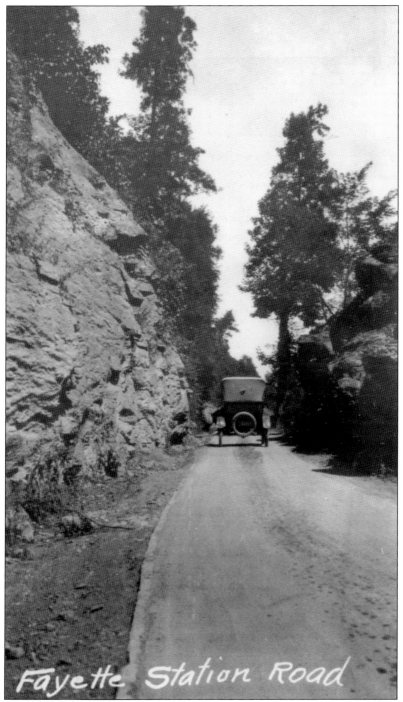

Fayette Station Road

Fayette Station Road, Route 82, was the main thoroughfare through the gorge for almost 100 years. Although paved, the road was never widened, and many portions remain one lane. Early vehicles were unable to complete the hairpin turns in one sweep and often had to back up again and again. Gasoline was originally unloaded from railroad cars in Fayette and trucked to stations along the top of the gorge.

The westbound local No. 13 train pulls into Fayette in the afternoon. Railroad camp cars on the left were home to traveling and permanent railroad workers. The wooden boardwalk cantilevered over the river and provided a safe walkway along the track. The house faintly visible on the right of the walk is home to the railroad section boss.

The small boy on the loading dock at the Fayette railroad station is J. C. Blume. Today's Fayette Station takes its name from the old railroad station at Fayette. J. C. Blume was one of the boys who burned down a garage trying to learn how to smoke cigarettes on top of a gasoline tank beside the Fayette Station depot. (Courtesy Sharon Cruikshank.)

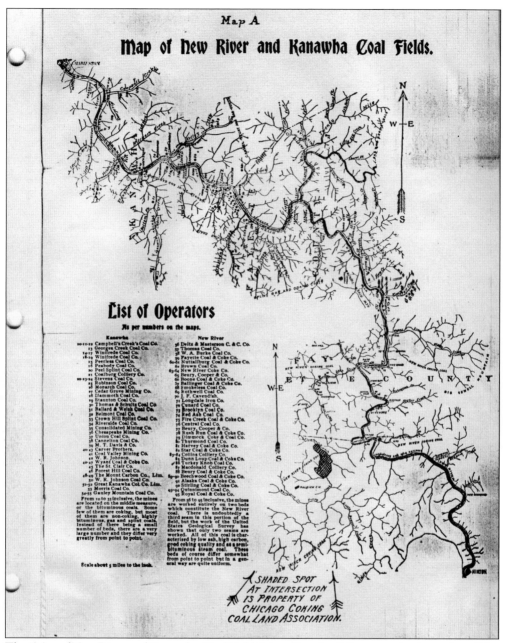

Map A

Map of New River and Kanawha Coal Fields.

List of Operators

As per numbers on the maps.

Kanawha

10-11-12 Campbell's Creek's Coal Co.
13 Georges Creek Coal Co.
14-17 Winifrede Coal Co.
18-19 Winifrede Coal Co.
18 Peerless Coal Co.
19 Peabody Coal Co.
20 Peel Splint Coal Co.
21 Coalburg Colliery Co.
22-23-24 Stevens Coal Co.
25 Robinson Coal Co.
26 Monarch Coal Co.
27 Cedar Grove Mining Co.
28 Hammett Coal Co.
29 Staunton Coal Co.
30 Thomas & Schmitz Coal Co
31 Ballard & Welsh Coal Co.
32 Belmont Coal Co.
33 Crown Hill Splint Coal Co.
34 Riverside Coal Co.
35 Consolidated Mining Co.
36 Chesapeake Mining Co.
37 Union Coal Co.
38 Cannelton Coal Co.
39 M. T. Davis & Co.
40-43 Carver Brothers.
42 Coal Valley Mining Co.
43 W. R. Johnson.
44-45 Wyant Coal & Coke Co.
46 The St. Clair Co.
47 Forest Hill Coal Co.
48-49 The Mount Carbon Co., Lim.
50 W. R. Johnson Coal Co.
51-53 Great Kanawha Col. Co. Lim.
53 Morris Coal Co.
54-55 Gauley Mountain Coal Co.

From 10 to 55 inclusive, the mines are located on the middle measure, or the bituminous coals. Some few of them are coking, but most of them are non-coking, highly bituminous, gas and splint coals. Instead of there being a small number of beds, there are a very large number and they differ very greatly from point to point.

Scale about 5 miles to the inch.

New River

36 Delta & Masterson C. & C. Co.
37 Thomas Coal Co.
58 W. A. Burke Coal Co.
59 Fayette Coal & Coke Co.
60-61 Nuttallburg Coal & Coke Co.
62 Brown Coal Co.
63-64 New River Coke Co.
65 Beury, Cooper & Co.
66 Boone Coal & Coke Co.
67 Ballinger Coal & Coke Co.
68 Smokeless Coal Co.
69 Rothwell Coal Co.
70 J. F. Cavendish.
71 Longdale Iron Co.
72 Cunard Coal Co.
73 Brooklyn Coal Co.
74 Red Ash Coal Co.
75 Fire Creek Coal & Coke Co.
76 Central Coal Co.
77 Beury, Cooper & Co.
78 Rush Run Coal & Coke Co.
79 Dimmock Coke & Coal Co.
80 Thurmond Coal Co.
81 Harvey Coal & Coke Co.
82 Star Coal & Coke Co.
83-84 Collins Colliery Co.
85 Dunn Loup Coal & Coke Co.
86 Turkey Knob Coal Co.
87 Macdonald Colliery Co.
88 Beury Coal & Coke Co.
89-90 Beechwood Coal & Coke Co.
91 Alaska Coal & Coke Co.
92 Stirling Coal & Coke Co.
93-94 Quinnimont Coal Co.
95 Royal Coal & Coke Co.

From 56 to 95 inclusive, the mines are worked entirely on two beds which constitute the New River coal. There is undoubtedly a third seam in this portion of the field, but the work of the United States Geological Survey has shown that only two seams are worked. All of this coal is characterised by low ash, high carbon, good coking quality and as a semi-bituminous steam coal. These beds of course differ somewhat from point to point but in a general way are quite uniform.

SHADED SPOT
AT INTERSECTION
IS PROPERTY OF
CHICAGO COKING
COAL LAND ASSOCIATION.

The "Map of New River and Kanawha Coal Fields" describes the different coal veins and qualities available in the region. Column two on the map lists the various companies operating in the New River fields of coal. Two beds of coal were being worked at the time. The blank spot that separates Fayette and Kanawha Counties is Gauley Mountain.

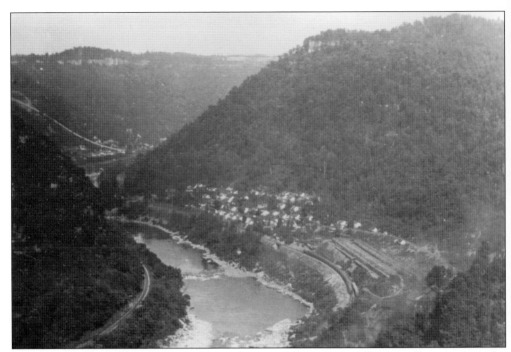

Kaymoor was divided into Kaymoor Top at the rim of the gorge and Kaymoor Bottom along the river. Coke ovens are visible in the photograph, as is a train in the lower right-hand corner. The town of Nuttallburg is just around the bend in the river. Bands of Nuttall sandstone form bluffs along the rim of the gorge.

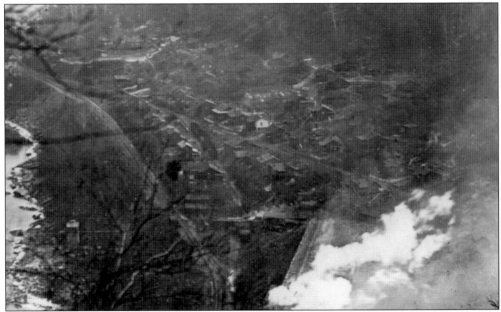

Steam from the coke ovens rises up from Kaymoor Bottom on a cold winter day. Water was used to quench the coke before loading it onto railroad cars. Ice is visible along the river's edge, and the tree limbs are bare. The smoke from the coke ovens, steam trains, and homes burning coal often left the sky dark and a dirty ash on every surface.

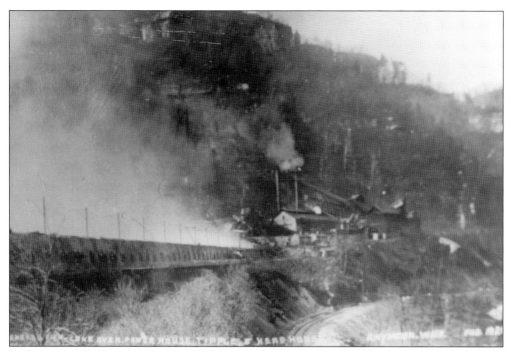

In February 1920, Kaymoor Bottom's double row of beehive coke ovens fills the sky with acrid smoke and steam. This view form the C&O mainline is just below the ovens, and the powerhouse is adjacent to the ovens. The coal-loading tipple is next to the powerhouse in the foreground of the picture.

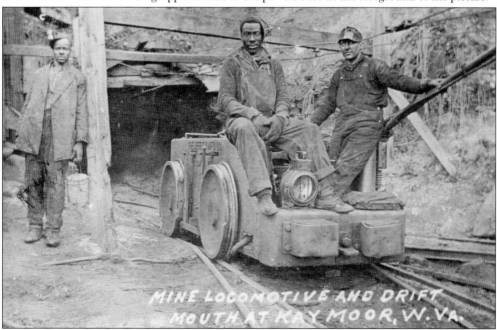

This postcard dated August 26, 1914, shows an electric mine locomotive just outside the drift mouth at Kaymoor, West Virginia. Electric mine locomotives replaced mules to haul coal cars from the mines. The miner on the right is leaning on the overhead electrical supply that powered the motor. Coal was delivered to the head house, where it was sorted, cleaned, and sent downhill to the tipple.

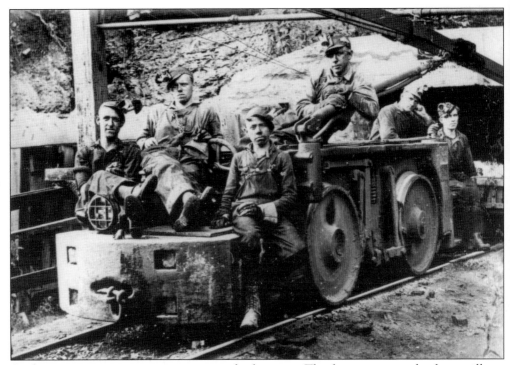

Coal miners sit on a mantrip motor outside the mine. The four miners in the front still use oil-burning lamps on their caps, while the two miners in the rear have carbide lamps. An open flame in the mine was dangerous, as it could ignite naturally occurring methane gas within the mine. Carbide produces acetylene gas and provides a brighter intensity and a reflector to focus the light.

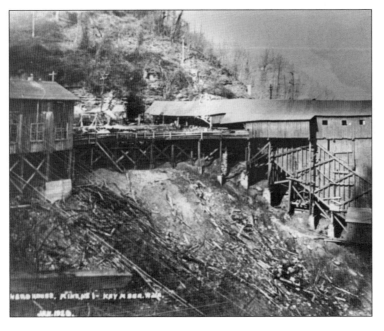

This photograph shows the head house and drift mine mouth at Kaymoor No. 1 mine as it appeared in January 1920. Kaymoor No. 1 was a large mine complex, with a top and bottom. Kaymoor No. 2 was a smaller mine located farther downstream, where the south support of the New River Gorge Bridge sits today. The head house sorted slate from the coal, sized it, and sent it down a monitor to the tipple.

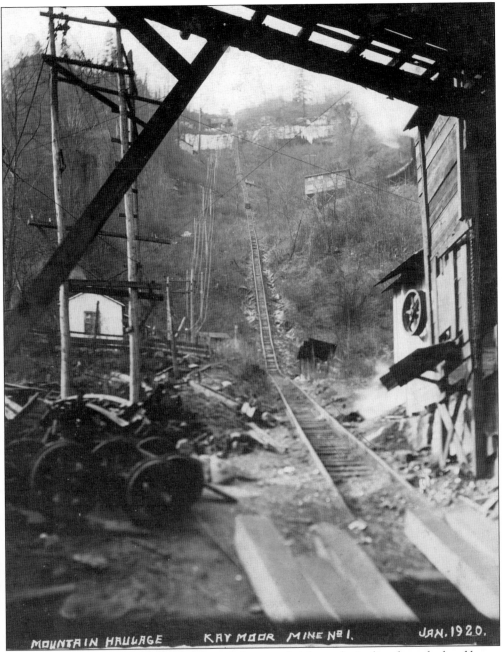

MOUNTAIN HAULAGE KAY MOOR MINE Nº 1. JAN. 1920.

The monitor was a long tube filled with coal that traveled down the incline from the head house to the tipple. As one loaded monitor traveled down from the head house to the tipple, it raised an empty monitor up to the head house. The monitor automatically opened at the bottom to dump its load. (Courtesy George Bragg.)

This January 1920 image shows the Kaymoor haulage at Kaymoor Bottom Mine No. 1. The haulage was a convenient way to move supplies and people between Kaymoor Top and Kaymoor Bottom. The two cars of the haulage worked like window weights. They ran on the same track and balanced each other: as one went down, the other went up. There was a double track in the middle where the two cars could pass as they met. It was common for people that worked in the gorge to ride the haulage as a part of their daily routine. Fayetteville resident Ruth Kidd started her career teaching school in Nuttallburg. Each morning she drove to Kaymoor Top, rode the haulage to Kaymoor Bottom, caught a train to South Nuttall, walked across the swinging bridge to Nuttallburg and taught school. She returned home by reversing the trip each evening. (Both courtesy George Bragg.)

John Woodson walks in front of the colored pool hall at Kaymoor Bottom. After Kaymoor was abandoned, railroad workers asked the railroad to provide flat cars so they could dismantle homes perched along the siding. The flat cars were then moved to Fayette Station, where the workers loaded the material onto trucks and transported it to be recycled into new homes.

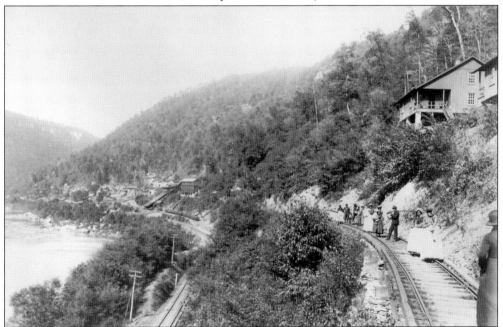

A mixed group of people walks along a railroad siding from Elverton to Caperton. Caperton was built in 1881 by George Caperton, who later became president of the New River Company. The town was also known as Mincar, Sugar Camp, and Victoria Coal and Coke. Rumors circulated that the mine's owner was Queen Victoria of England. Towns in the gorge frequently changed names as the mines were sold to different interests.

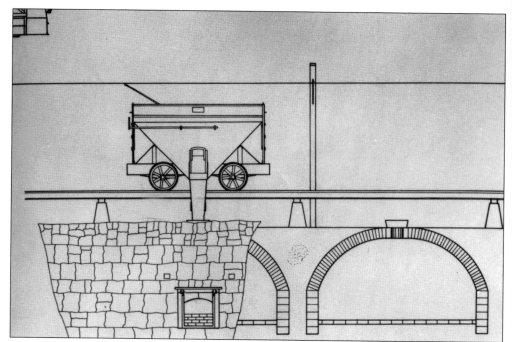

This schematic of the coking process shows a coal hopper traveling along the top of the coke oven to deposit coal into the oven, which is then sealed for the coal to be baked. The oven is unsealed by removing bricks stacked in a side opening. Coke is pulled from this opening and loaded onto waiting cars.

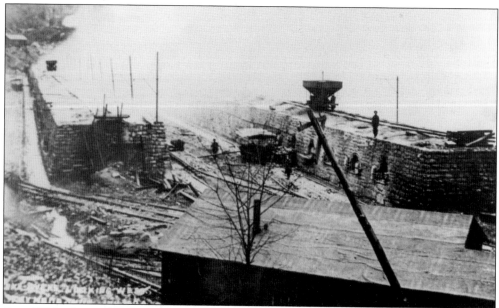

Over 200 beehive coke ovens converted coal into coke at Kaymoor Bottom. Coke is made when coal is baked at high temperatures in an oxygen-free environment and water, coal gas, and coal tar are burned off. The nearly pure carbon that remains enables coke to burn extremely hot. Coke is used as a fuel to produce steel. Modern coke ovens capture the escaping gases and manufacture additional products.

Four

Nuttallburg to Fire Creek

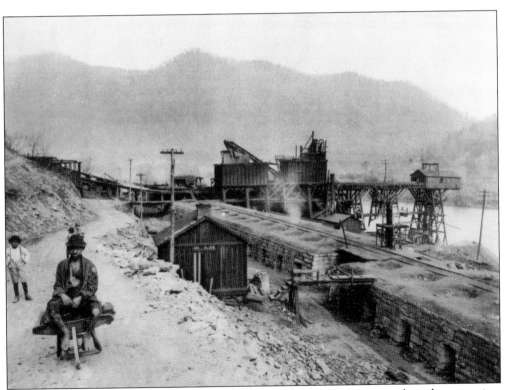

One of the earliest known pictures of Nuttallburg, taken in 1897, is on a glass plate negative. Four children play on a dirt road along the coke ovens while a barefoot boy in the front sits on a wheelbarrow full of house coal. A rope is tied to the front of the wheelbarrow to help pull it up the steep paths.

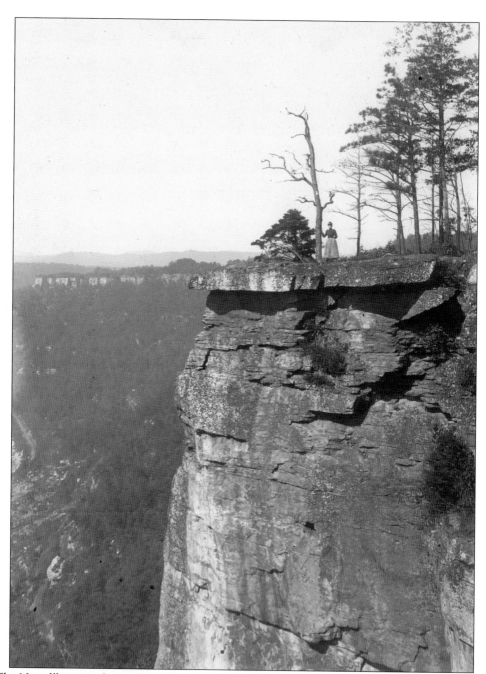

The Nuttallburg tipple is only a small detail in the lower left of this breathtaking view over the New River Gorge. The endless wall of Nuttall sandstone led to an unusual land issue in Fayette County. Farmers resented paying property taxes on the shear rock cliffs and did not pay taxes on those lots on the rim of the gorge. Farmers also were happy to sell their "worthless" and inaccessible mineral rights to vast tracts of land for pennies per acre to out-of-state buyers. Astute local land agent Morris Harvey bought the lots along the rim for back taxes and gained easy access to the minerals. Since the face of the coal seams opened out into the gorge, Morris made his fortune selling easy access to the coal. (Photograph by J. K. Hillers, courtesy USGS.)

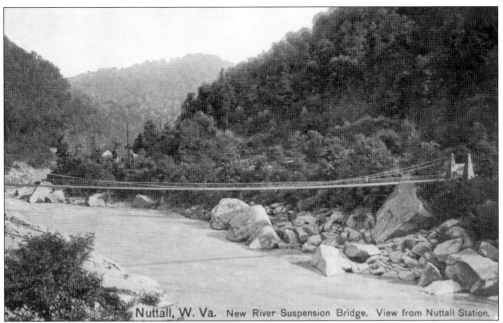

Nuttall, W. Va. New River Suspension Bridge. View from Nuttall Station.

This postcard of the New River Suspension Bridge at Nuttallburg, West Virginia, was mailed from Kaymoor. The bridge was composed of cables suspended from two stone towers on each side of the river. It connected Nuttallburg to the town of Browns, later renamed South Nuttall.

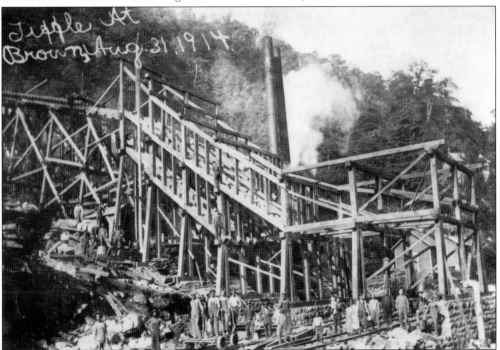

Construction workers pose for a picture in various spots on the tipple at Browns, later South Nuttall. One man stands atop the timber near the center of the picture with his back turned to the photographer. Tipples required large quantities of hardwood, which was readily available in the nearby forest. Houses are visible behind the framework.

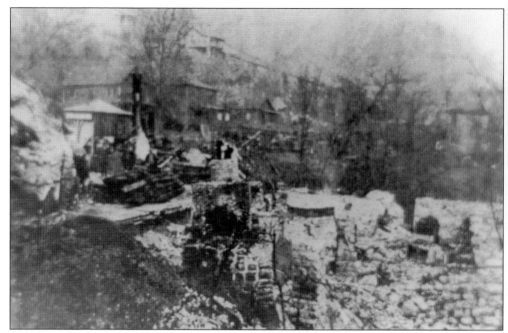

The April 15, 1944, *Charleston Gazette* reported a landslide at South Nuttall. The article identifies the house on the hillside as the Bennetts'. Other buildings in the photograph are identified, from left to right, as Old Club House (Simmons), Combs, Jimmy Domingues, Otto Domingues, Sam Salendow, Coleman house, and Club House (Simmons). The rubble in the foreground is all that is left of the New River Smokeless Company store.

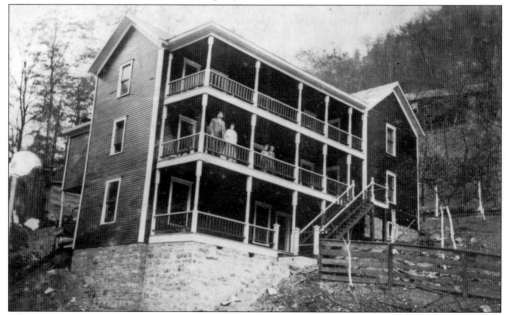

Pictured around 1914, the Eli Taylor house in South Nuttall (Browns) was built by Crockett W. Creger and Wayne Feazell. It is a three-story balloon frame house on a stepped stone foundation. Homes of this size were reserved for wealthy merchants and mine company executives. Eli Taylor was the mine superintendant at South Nuttall.

From left to right, Betty Alexander, Charlotte Simmons, and Jean Wilson ham it up for the camera in South Nuttall in 1935. While life was dangerous and the work was hard, residents often spoke longingly of the great friends and fun times they remember from living and working in the coal camps.

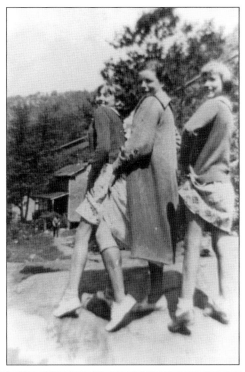

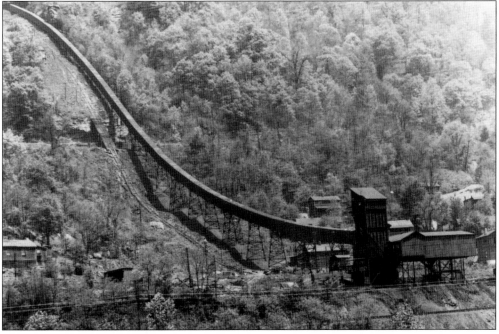

Nuttallburg was a favorite subject of photographers and a distinctive landmark. Each company used its own system to transport coal from the bench level of the mines down to the railroad. Methods included shuttle cars that automatically dumped when they reached the bottom and, later, mechanical belts. Nuttallburg used the "rope and button" system, which relied on a knotted rope dragging wooden "buttons" down a wooden chute. (Courtesy George Bragg.)

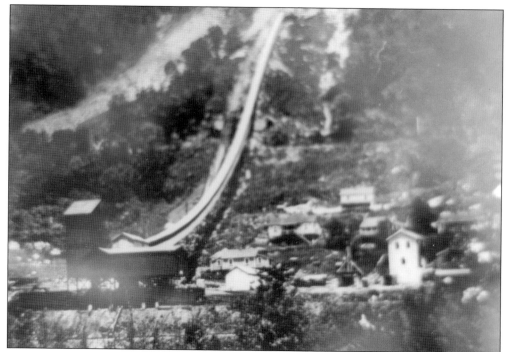

This spring 1927 image of Nuttallburg Mine, owned by the Fordson Coal Company, shows many details. The prominent building to the far right with the two-over-one windows houses the water system. Preacher Hubbard lived in the house with four windows beside the tipple. Founded in 1880 by Englishman John Nuttall, the mine and town were sold by the family to Henry Ford in 1920.

Nuttallburg Grade School was built in 1926. Constructed of cinder block, the school had two rooms, a coal stove in each room, and outside toilets. Children in grades one through eight attended the school. Most schools in the gorge only went to eighth grade. After eighth grade, boys would accompany their fathers to load coal in the mines.

Taking a break from their magazine sales, two unknown Kaymoor girls pose for a picture on the swinging bridge between Nuttallburg and Browns in the 1930s. The house in the background is mine superintendant Housekenct's residence.

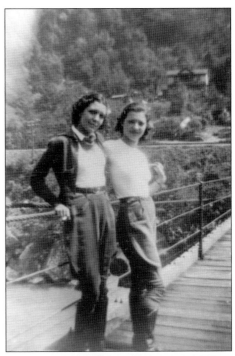

This winter view of the Nuttallburg mine under construction looks west from Beauty Mountain. A light snow has fallen and highlights the tipple and button line. The snow also reveals the railroad and the remaining forest. Eventually large portions of the gorge were stripped of trees for either timber or firewood. With steam trains belching hot cinders from their stacks, forest fires were a constant threat.

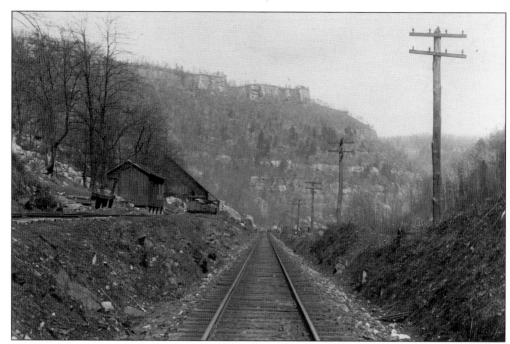

USGS photographer M. R. Campbell captured these opposing views in 1895. A view looking downstream from the C&O Railroad tracks just below the Nuttall Mines (above) shows the cliffs of Fayette sandstone in the distance. This is a excellent view of the rock strata that Prof. I. C. White detailed in his 1894 drawing *Coal Sections of the Great Kanawha Basin*. Looking back toward South Nuttall, Campbell captures the great vista and depth of the lower gorge, with Beury Mountain visible in the background (below). (Both photographs by M. R. Campbell, courtesy USGS.)

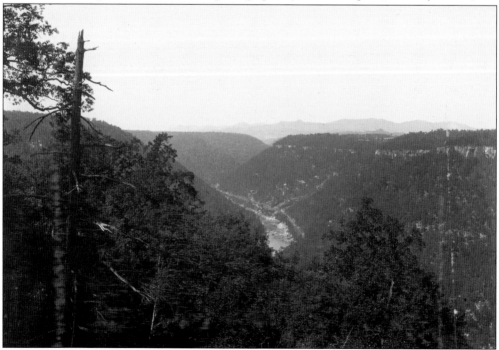

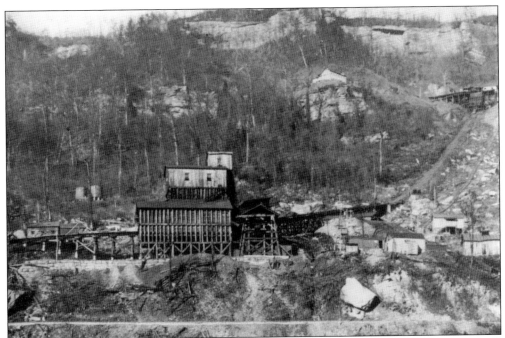

This close-up view of the Elverton coal tipple shows the massive Nuttall sandstone bluffs rising nearly 700 feet in the background. In the upper right is the head house and haulage system. As coal left the mine, it was sorted, and slate was removed and often left where it fell. A large boulder, comparable in size to the workers' shanties, lies above the railroad track. The Elverton mine closed in 1951.

Federal agents with bloodhounds arrive to investigate the blowing up of the electric tower at Elverton during the coal strike of 1921. By 1920–1921, a severe economic depression turned the southern West Virginia coalfields into a tinderbox of labor unrest and violence. The boy in the foreground is George Allen.

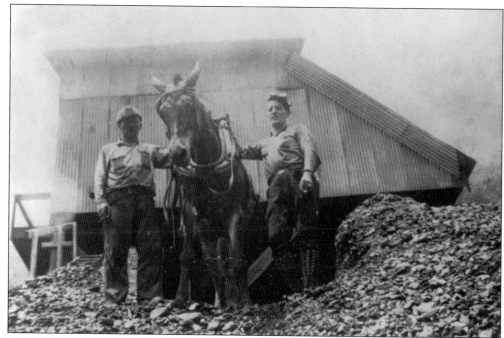

Gene Rhodes (left) and Jesse Bragg are pictured with their company mule, Old May, in front of the Brooklyn coal tipple. The mule and plow were used to move slag out of the way. Employees were eligible to borrow a company mule to plow their gardens in the spring. It was often said by miners that the company cared more for its mules than its miners because it had to purchase the mules.

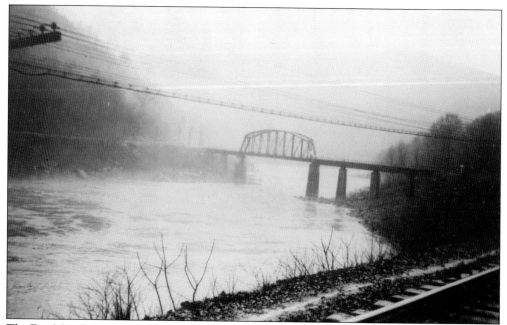

The East Main Line railroad trestle crossed the New River west of Sewell. Rail lines were developed on both sides of the gorge to facilitate efficient mining. Rapids in the river at this point later became known as "upper" and "lower railroad" because of their proximity to the trestle.

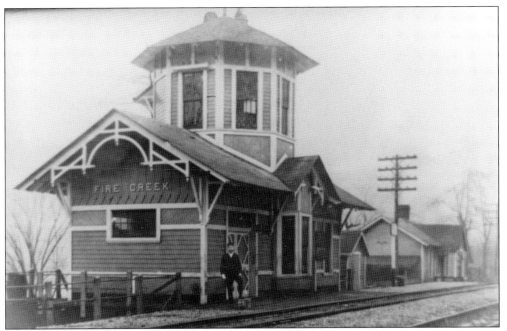

Stationmaster Clarence Smith stands in front of the Fire Creek depot. The building in the background was washed out in 1926 or 1927. The Fire Creek depot defines C&O railroad depot architecture at the time. While each one was unique, a common theme of board-and-batten construction, ornate rooflines, and gingerbread trim provided uniformity along the line.

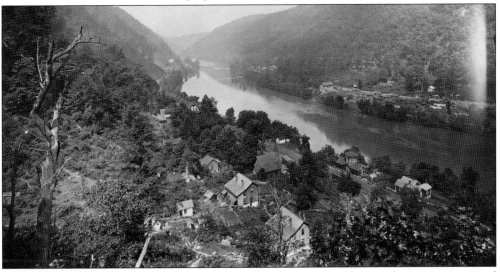

This bird's-eye view of Fire Creek looks east from the community of Sunnyside, or upriver, toward Beury, with the Beury Catholic Church discernible in the distance. Fire Creek depot and a variety of houses, shanties, and outbuildings show up well on this clear day in 1899. Fresh laundry is visible in the yard of a home in the center of the photograph. Smoke rises from the coke ovens between the tracks and the bottom of the photograph. A team of horses pulls a coke wagon to load on the train. A shortage of coal cars led to the use of old boxcars to haul coke. Slats were nailed across the doors and coke was piled inside. The last two cars in the string of coal cars are boxcars with their doors boarded shut. (Photograph by J. K. Hillers, courtesy USGS.)

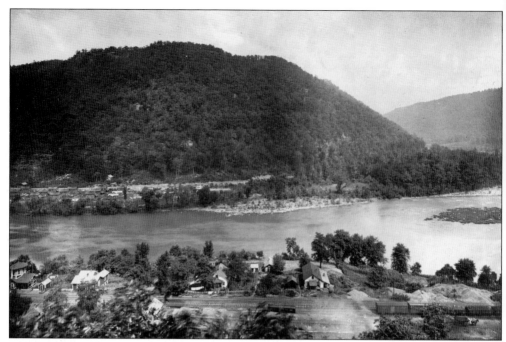

John "Jack" K. Hillers took this photograph of Fire Creek in 1894. Hillers was a photographer who traveled the continental United States for the USGS. He was hired by John Wesley Powell as an oarsman for his second expedition down the Colorado River. Hillers learned photography on the trip. He retired in 1908. (Photograph by J. K. Hillers, courtesy USGS.)

Archie Diggs was an African American who used a mule and sled to haul coal, freight, supplies, and staples to residents' homes. As people left the gorge, the remaining individuals eked out a living providing whatever services they could. As mines mechanized or shut down, the need for labor was drastically reduced. By 1950, most mines in the gorge had already closed or would be closed in a matter of years.

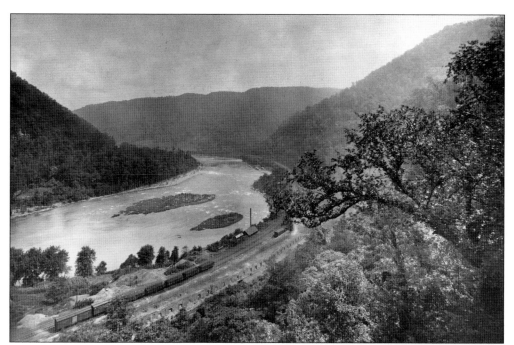

This panoramic view from Sunshine Mine of Fire Creek in 1899 is the third picture in a series of three and depicts the true beauty of the New River Gorge. It evokes the serenity, peace, and solitude the first settlers to the area must have experienced. With the protection provided by national park designation, these elements are again available to visitors. (Photograph by J. K. Hillers, courtesy USGS.)

Mrs. Grove sits on her suitcase as she poses for her 80th birthday portrait in front of the Kincaid house. Fire Creek flowed between these houses. The black school, which also served as a church, sits below the cliffs. The Higginbottom house is to the right, and the Nelson house sits behind it.

The Fire Creek depot sits on the left, with the tipple across from it. In the center is the Kincaid home, and to the right is the house where mine superintendant Vessie C. Perkins lived. Also visible are the Kincaids' chicken houses, garden, daughter Mary Louise's playhouse, and a grape arbor. At the lower right, a railroad-car shanty provides housing for new or temporary track workers.

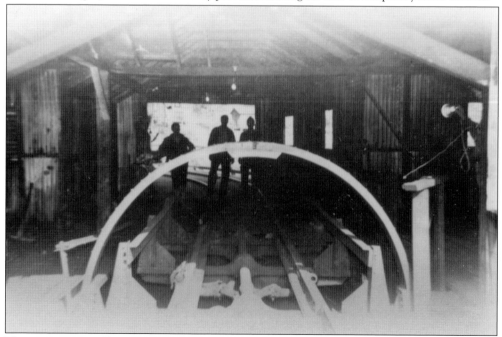

Three miners are silhouetted against the rotary dump at Fire Creek. The rotary dump unloaded the coal cars as they left the mine by grasping and spinning them upside down, dumping the coal into the head house for its trip down the mountain.

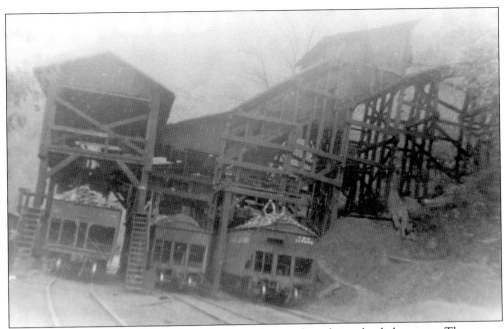

A close-up view of the Fire Creek tipple shows three railcars being loaded at once. The car on the left is filled with large coal, the smaller middle car is filled with fine coal, and the car on the right is filled with medium-sized coal. A workman on top of the car on the right is leveling the shipment to avoid spillage during transport. Children would often walk the railroad tracks, collecting spilled coal to heat their homes or sell.

Russell Raymond Kelly Jr. poses with his dog, Sang, in this 1941 family photograph. Family members recall Russell as an accident-prone child and remember him always having a broken bone or getting hurt. (Courtesy Sylvia Hardy.)

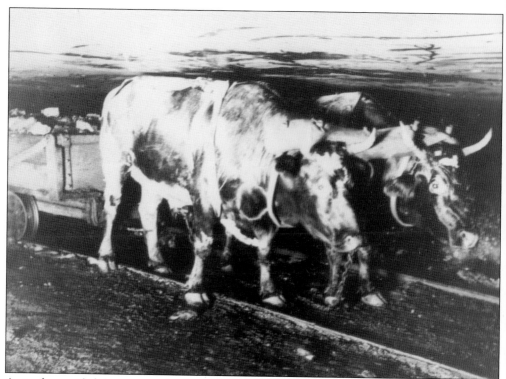

Animals provided the power to haul coal from the mines before electric motors. The Sewell seam was 48 inches high. Before mechanization, miners only removed the coal. Today's equipment can remove the coal plus extra stone to make the mines larger. Depending on the height of the mine, workers would use baskets, dogs, ponies, oxen, and mules.

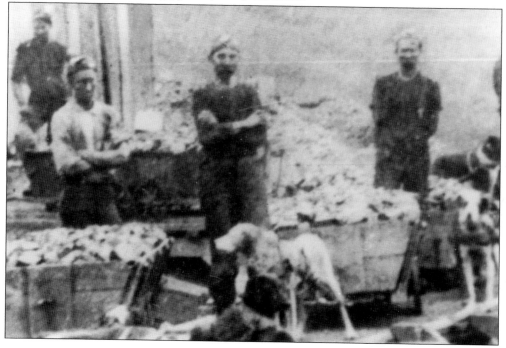

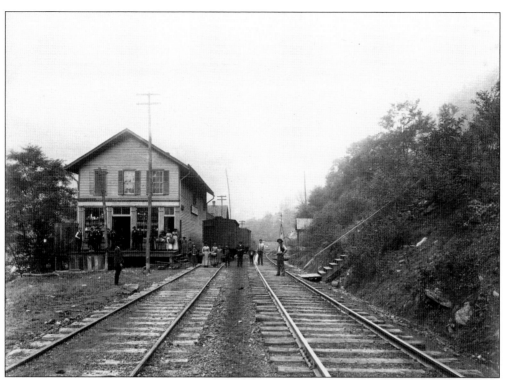

African Americans line up for a photograph on shopping day at the Caperton Company Store. While the coalfields were a diverse place, groups remained segregated. Barriers included race, language, ethnicity, and religion. Most residents agreed, however, that segregation was only above ground. Once in the mines, it was man against nature, and everyone's life depended on the man next to him regardless of color. (Courtesy George Bragg.)

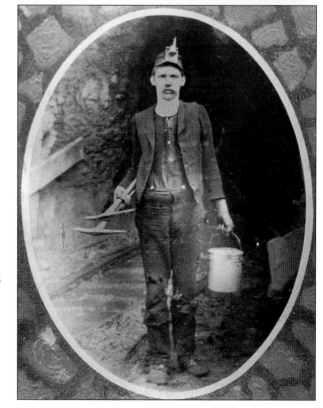

Joseph Beury carries the tools of the miner's trade. He has a miner's lunch pail in his left hand. The pail had three layers, providing storage for drinking water in the bottom and food in the top. His lamp is a lard oil lamp. Lard melted from the heat of the flame and soaked the wick to produce a flame. (Courtesy George Bragg.)

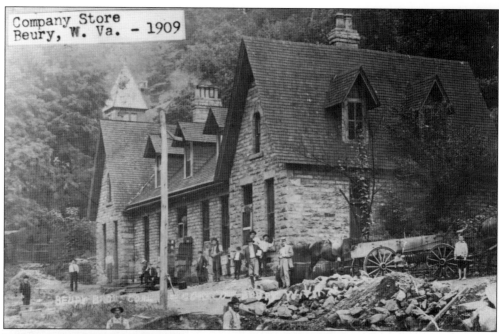

Company Store
Beury, W. Va. - 1909

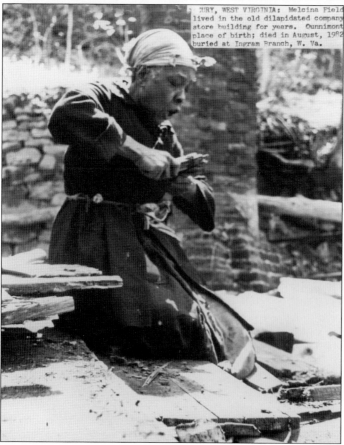

URY, WEST VIRGINIA: Melcina Field
lived in the old dilapidated company
store building for years. Cunnimont
place of birth; died in August, 1982
buried at Ingram Branch, W. Va.

All work has stopped as the photographer captures this shot. The Beury company store was a massive cut-stone building with two wings and multiple fireplaces. A church spire rises behind the store. Henry B. Beury, son of owner Joseph Beury, stands at the corner in a light-colored suit. (Courtesy George Bragg.)

Known as the Hermit of New River, Melcina Fields worked as a servant for the Beury family. After the Beury mansion collapsed, she lived in the decaying remains of the Beury company store until her death in 1982. People from neighboring towns left supplies for her along the railroad tracks. They also built a hut for her, but she preferred to live in the remains of the old store building.

Coal operator Joseph L. Beury built his family a 22-room mansion complete with a greenhouse, swimming pool, and stables. Beury's wealth stemmed from shipping the first railroad car of coal out of the New River Gorge from Quinnimont in September 1873. He followed up on his early success and founded the community of Fire Creek three years later, in 1876.

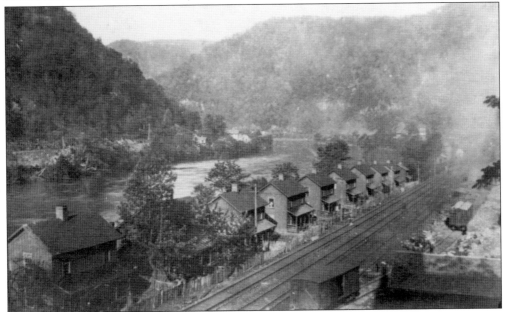

The Beury Coal Company mining camp needed more living space by 1915. The increased housing and the lack of space forced homes to be built between the railroad tracks and the river. The two-story, board-and-batten, gable-roofed houses were built on every available lot. Residents counted the trains as they passed and knew what time it was by the train schedule. (Courtesy George Bragg.)

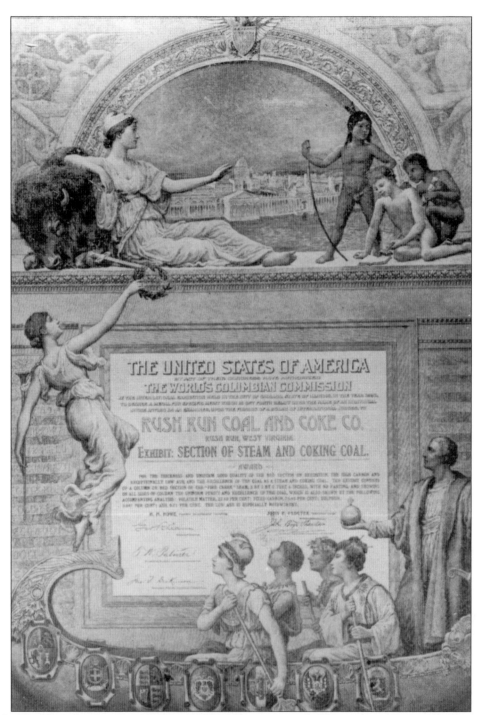

The World's Columbian Exposition of 1893 in Chicago awarded first prize to the Rush Run Coal and Coke Company for the thickness and conformity of its steam and coking coal. A cubic yard of coal was displayed and analyzed at the fair. The coal mined in the gorge is metallurgical coal and is prized for its heat and clean burning. At one time, half of the world's navies relied on New River smokeless coal.

Five

THURMOND TO GLEN JEAN

Capt. William Dabney Thurmond incorporated the town of Thurmond in 1903. Thurmond worked as a surveyor after his service in the Confederate army and obtained the land as payment in 1873. In a prime location along the coming railroad route and with a potential for a connection to the south side of the New River, Thurmond's town would soon become the freight leader for the entire C&O. (Courtesy George Bragg.)

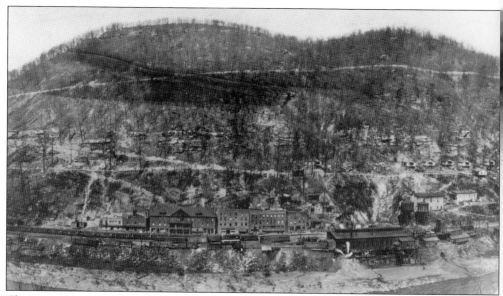

This panoramic view of Thurmond was taken by Rufus "Red" Ribble as plate two of three in a series. Thurmond's Commercial Row includes a drugstore, jeweler, bank, two hotels, and an Armour meatpacking plant but no Main Street. The steep mountainside and the C&O's double tracks left just enough room between the buildings for a sidewalk. Across the tracks, the railroad built an engine house and other maintenance buildings.

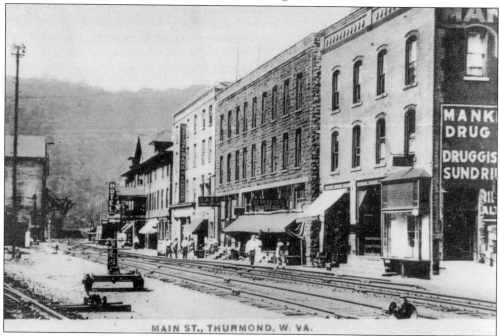

MAIN ST., THURMOND, W. VA.

Known as the "town without a Main Street," and "the Dodge City of the East," Thurmond eventually grew to 500 residents. The Masonic lodge, however, was rumored to have over 1,000 members as Thurmond became the social and economic center in the late 1890s. By 1900, there were 26 mines operating around Thurmond, and a new railroad trestle connected Thurmond to Dunloup Creek's rich coalfields across the river.

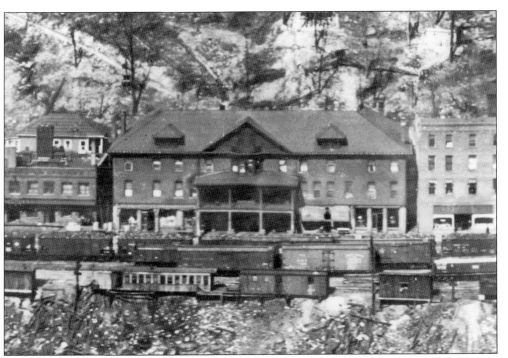

Captain Thurmond built the Hotel Thurmond in 1891. A devout Baptist, Thurmond refused to allow alcohol or other vices in his town. Thurmond's uncompromising beliefs lead Thomas McKell to build the Dunglen Hotel across the river. McKell capitalized on Thurmond's virtue by luring visitors across the river to drink and gamble. When Thurmond tried to extend his control across the New River, McKell annexed the Dunglen into his own town of Glen Jean.

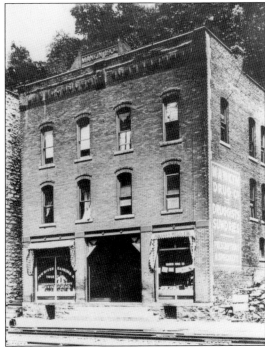

The Mankin Building was completed in 1904. It sat on the only lot in Thurmond that Captain Thurmond ever sold. He regretted the decision and later bought the lot and building back. The structure originally housed the National Bank of Thurmond and Mankin Drug. Mankin Drug changed its name to Kelly Drugs and moved to Main Street in Oak Hill, West Virginia, in 1935 during the Depression.

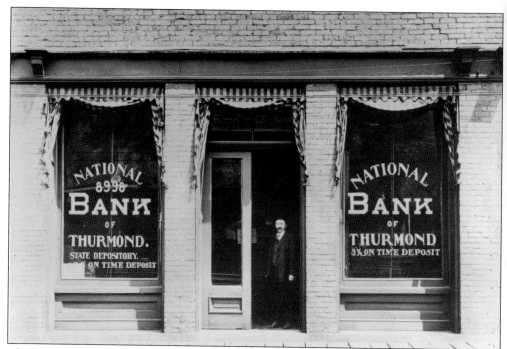

The National Bank of Thurmond was established by Thomas McKell on August 11, 1904, and was located in the Dunglen Hotel. In 1911, the bank moved across the river to the Mankin Building in Thurmond, where it stayed until it failed in 1931. Thurmond's other bank, New River Banking and Trust Company, moved to Oak Hill in 1935. (Courtesy Tim Richmond.)

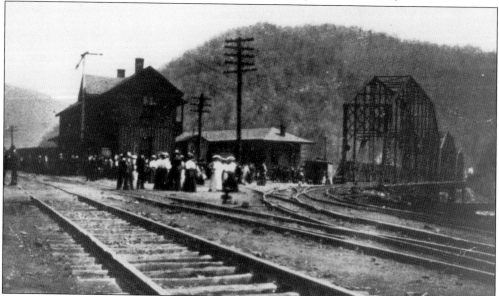

A large group of ladies is gathered in their finest dresses and hats at the Thurmond depot on November 10, 1907. A *New York Times* article of the same day estimated that the total net worth of all railroads in the United States was approximately $11 billion. The article was written in disappointment, as government estimates indicated that the railroads had lost $2 billion in the ongoing economic troubles.

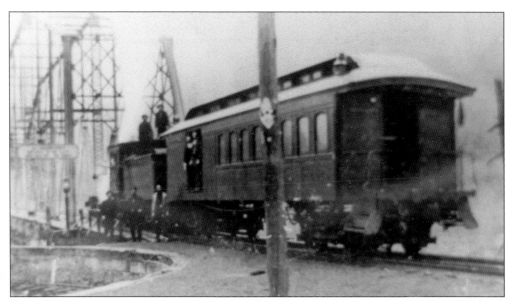

A local passenger train prepares to cross the Thurmond trestle to the Southside or Ballyhack district of Glen Jean. A massive flood washed out the original trestle in 1908. The roundtable was removed when the new trestle was rebuilt in 1915. While numerous freight trains and passenger trains brought people and freight to the gorge each day, it was the local trains that transported people within the gorge.

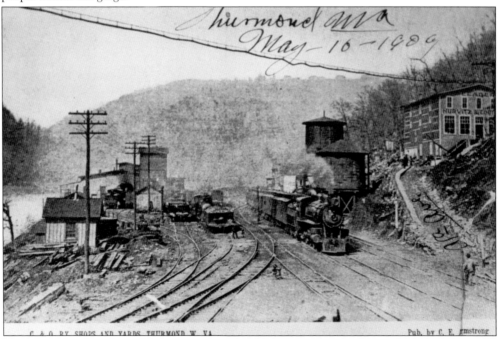

Thurmond developed a sizable maintenance yard. Two main tracks ran through town with several sidings available to switch cars and engines to the maintenance yard. Thurmond was essential to steam locomotives that needed to replenish their water and coal between Gauley Bridge and Hinton. Trains also required sand to provide traction as the trains climbed the slow but steady elevation along the New River. (Courtesy George Bragg.)

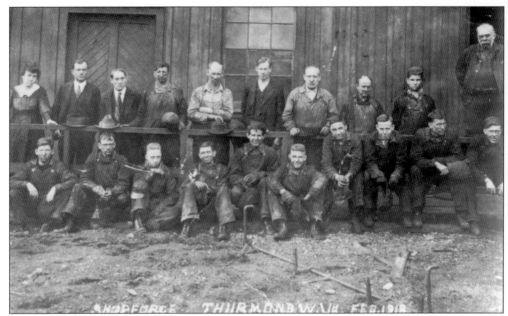

In February 1918, the Thurmond Shop Force poses for a group photograph. The names of the men in the first row are not recorded. Standing, from left to right, are four unidentified, ? Gipson, Comer Gray, Comer's father (known as "Old Man Gray") Finely Meadows, H. A. Brightwell, and "Dad" Nugent. Servicing 60 to 100 cars daily, 50 to 70 men worked in the engine house.

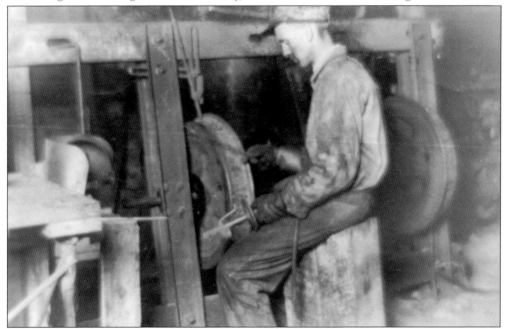

C. T. Suthard repairs a train wheel at the Thurmond machine shop in 1923. Steam locomotives were maintenance-intensive, and the maintenance yard stayed busy. The engine house was expanded when the C&O added Mallet locomotives to its lineup. The Mallets were compound locomotives that reused steam from their engines to create additional power. Although very complex, the C&O found them especially useful for the slow, heavy work in the coalfields.

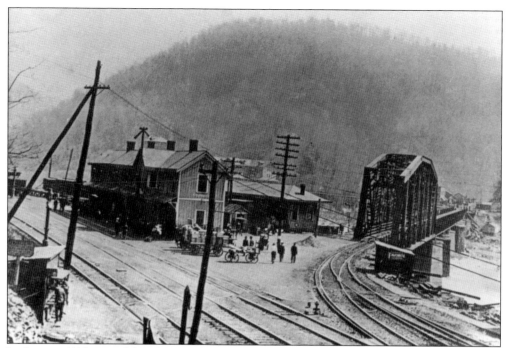

In this post-1915 view of the Thurmond depot, the new trestle has been constructed, the roundtable has been removed, and a freight house has been built between the depot and the river. In the background, just visible above the roof of the depot, is the roof of the Dunglen Hotel. Across the river is the Ballyhack district. A lunch counter, the Dog Stand, operates in the lower left.

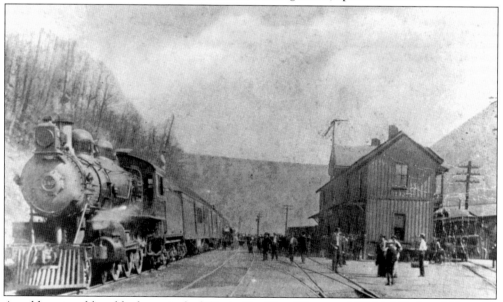

An old postcard heralds the arrival of "Train No. 13 at Thurmond W. Va." To board Train 13, passengers must stand in the middle of one of the most active mainline railroads in the United States. The C&O connected Washington, D.C., Cincinnati, and Chicago. Travelers could read the *Washington Post* and eat fresh Chesapeake Bay seafood for dinner. In 1910, seventy-five thousand travelers passed through the depot. (Courtesy George Bragg.)

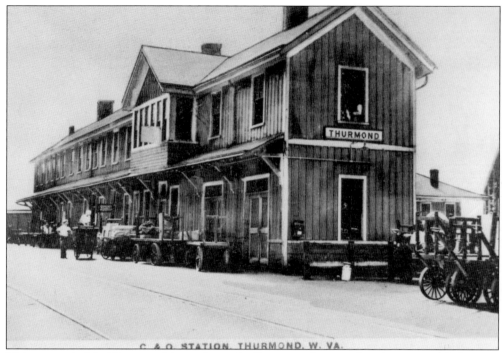

This postcard of the Thurmond depot shows the flag out, indicating that the train needed to stop for a pickup. The yardmaster is visible in his office just above the Thurmond sign. Although each depot along the line was built in a consistent style, the architectural details varied sufficiently so that those who could not read would still know where to disembark.

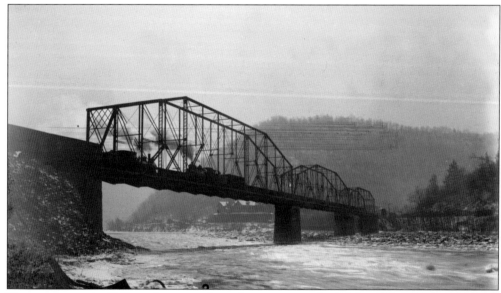

Two trains meet in 1907 on the original trestle connecting the C&O in Thurmond to McKell's Kanawha, Glen Jean, and Eastern Railroad (KGJ&E) in Glen Jean. Thomas McKell built the original trestle to transport the vast coal deposits of the Dunloup Creek area. A dispute with the C&O over marketing the coal led McKell to connect the KGJ&E to the Virginian Railroad, and the bridge only carried foot and automobile traffic. (Courtesy George Bragg.)

One famous New River legend tells of a local miner who consolidated several small mines and sold out for a fortune before leaving town. Here Paddy Rend is shown holding the $1.2 million check for his Minden mines. After this photograph was taken, Rend walked to the Dunglen and bought the house a drink. After that, he boarded a train, never to be heard from again. (Courtesy George Bragg.)

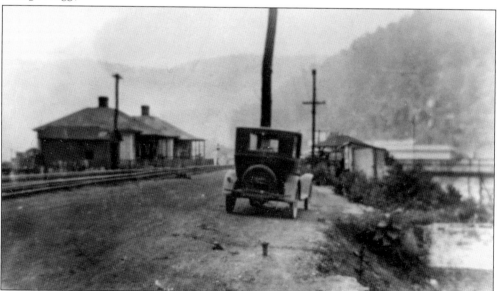

Wallace Bennett's Ford sits at Southside Junction, across the river from Thurmond. Wallace was a railroad employee and at one time or another had lived in both houses to the left of the railroad tracks. This area was also known as the Ballyhack district, home to numerous bars and brothels. The need for flat land for housing often resulted in the removal of trees and the filling of ravines in the narrow gorge.

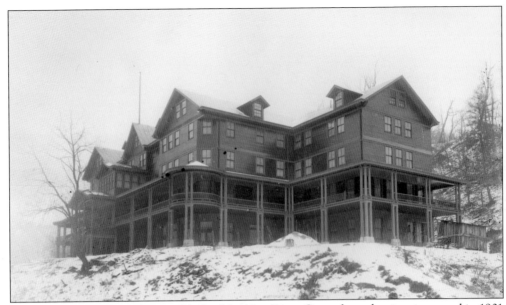

The Dunglen Hotel was the social hub of the New River Gorge from the time it opened in 1901 until it burned in 1930. *Ripley's Believe It or Not* recorded that the world's longest continuous poker game ran from the hotel's opening in 1901 until July 1, 1914, when Prohibition began in West Virginia. Known for its lavish accommodations, it was often referred to as the "Waldorf Astoria of the Mountains." Rooms rented for $2.50 a night, which was more than miners earned in a week. Outside the Dunglen, cheaper saloons sold whisky by the quart, and weekends would find miners and train crews spending their pay on liquor and prostitutes. Captain Thurmond's distressed family later published *Two Views of Thurmond: On Hundred Years of History* to dispel the myths and separate Thurmond from the vice across the river. (Above, courtesy George Bragg; below, courtesy Tim Richardson.)

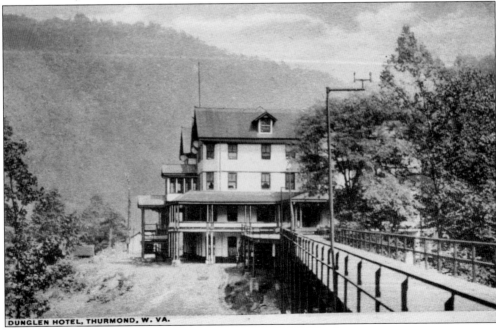

DUNGLEN HOTEL, THURMOND, W. VA.

Thurmond's sheriff, Harrison Ash, operated this bar across the river from Thurmond in the Ballyhack. Standing on the porch are, from left to right, Al Treadway, John Johnson, Jeff Johnson, and Henry Brown. Ash had a fearsome reputation and was reputed to have seven notches on his pistol. An early newspaper article sensationalizing the violence remarked that "the only difference between hell and Thurmond is Thurmond has a river running through it."

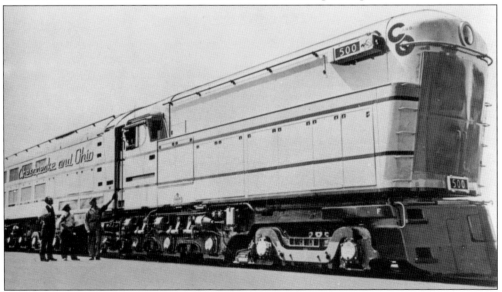

The end of World War II brought the end of steam locomotives, and the C&O converted to diesel. Unit 500, photographed here in 1949, spelled the end for places like Thurmond. Towns along the New River rail lines had been laid out to replenish the steam engines' thirst for water and coal. After the coming of diesel engines, service shops were consolidated in Hinton, West Virginia, and fuel and water stops abandoned.

An eastbound train passes through the remaining homes at the west end of Thurmond's Commercial Row around 1950. Visible at the head of the train is the three-story coaling tower, a reinforced concrete structure constructed in 1920 to provide coal for steam locomotives. By the 1950s, modern streetlights had come to the area, and individuals, not the town, now owned the homes and land.

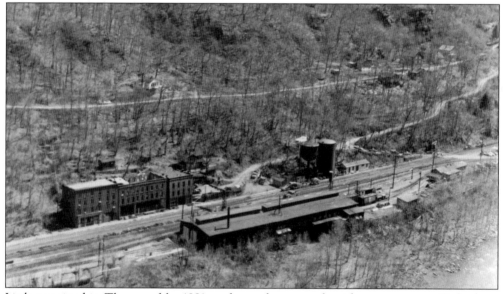

Little remained in Thurmond by 1981, and most houses and residents were gone. Only three structures remained on Commercial Row, and the roof on the center building had collapsed. The lone remaining business, the Banker's Club, a restaurant and motel, was located in the old Thurmond bank building. The engine house in the bottom of the photograph would burn down in 1991. Cars wait near the railroad crossing.

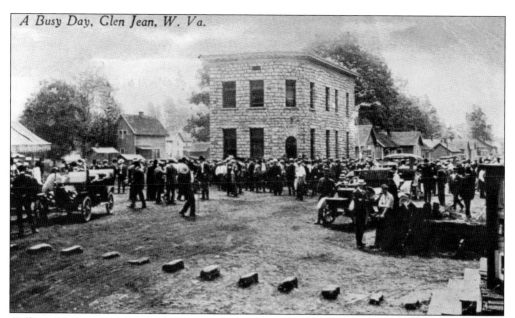

A Busy Day, Glen Jean, W. Va.

William O. Trevey took this photograph from the steps of his studio. Trevey traveled through the New River coalfields taking pictures of everyday events. Stepping-stones in the foreground kept pedestrians' feet clean as they crossed the muddy streets. Old timers fondly recall that ice cream was only available on the Fourth of July, brought in on the train for the celebration.

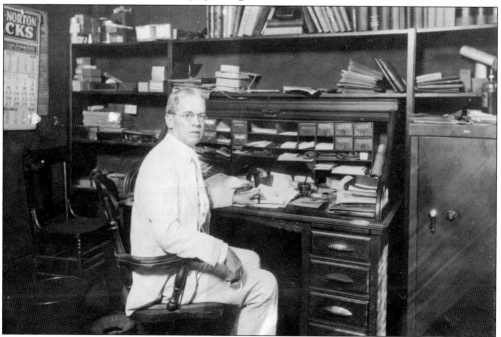

William "Bill" McKell, son of Thomas McKell, sits at his desk in the Glen Jean Bank on August 19, 1930. McKell's family developed the area from Glen Jean to Thurmond, and he spent his life overseeing their holdings. Bill McKell's fiancee came to visit and started to complain about everything in town. He promptly returned her to the station and put her back on a train to Ohio. McKell never married.

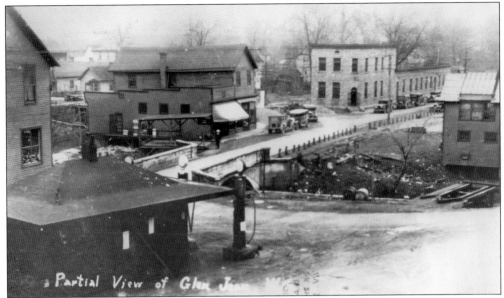

Thomas McKell built the Bank of Glen Jean in 1909 to protect his wealth. The bank is constructed of sandstone walls, while the floors and roof are steel. A single-story addition was built in 1917. Violence against coal company structures was common, and McKell also purchased a set of machine guns to protect his holdings. The guns were stolen during the 1920–1921 mine wars. (Courtesy George Bragg.)

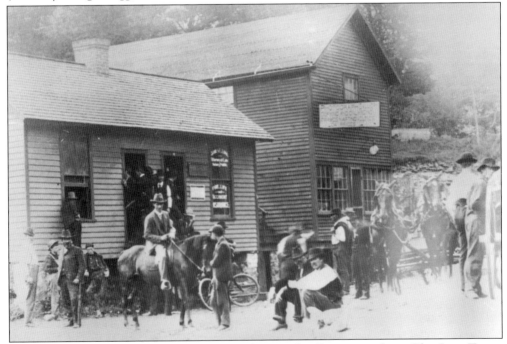

A crowd gathers as William O. Trevey takes a photograph of his own studio in Glen Jean. Trevey traveled through the New River Gorge taking pictures of everyday events. His glass plate negatives were discovered in the 1980s in the second story of a nearby building that originally served as the town's athletic club. Trevey's studio was situated diagonally across from the Glen Jean Bank.

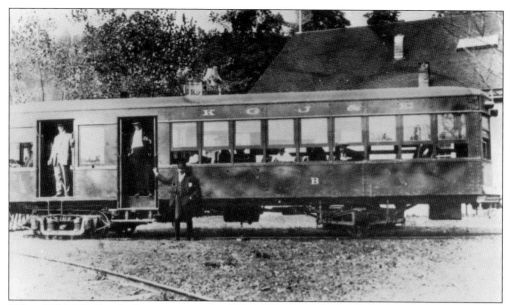

When Bill McKell rode the streetcar on his KGJ&E Railroad, he made sure he paid his nickel fare. He stated that he wanted to make the point that everyone had to pay. McKell was a paternalistic owner and vowed never to unionize. Miners that worked for him were blacklisted and were not hired in union mines. McKell eventually closed his mines to avoid unionization.

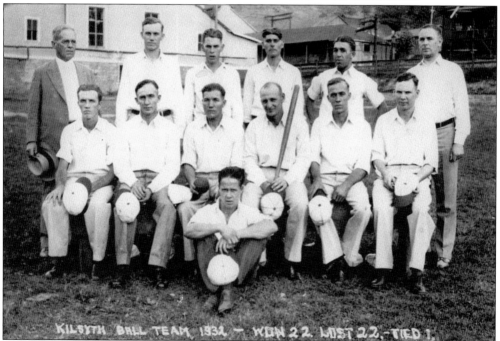

Most coal camps fielded at least one baseball team and traveled to other coal camps to compete. Bill McKell is credited with inventing the game "Let 'em hit it" to level the playing field. The point of the game was for the pitcher to throw a hit. Too many strikes would get him relieved. McKell felt the game was more exciting and encouraged everyone to participate. (Courtesy George Bragg.)

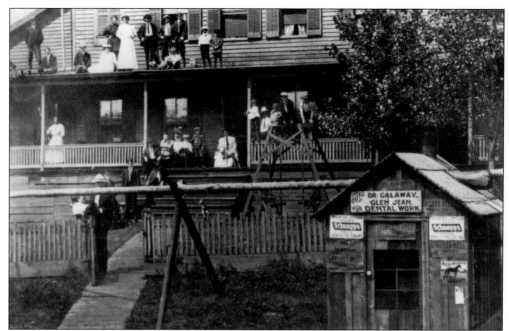

Guests line the roof and front porch of a Glen Jean boardinghouse near Collins Colliery Company Store. The boom in the coalfields created a transient lifestyle, and vast numbers of immigrants, salesmen, and travelers needed affordable lodging. Since most of Glen Jean was in a low-lying area, gravity-fed city water supply runs above ground in front of the house.

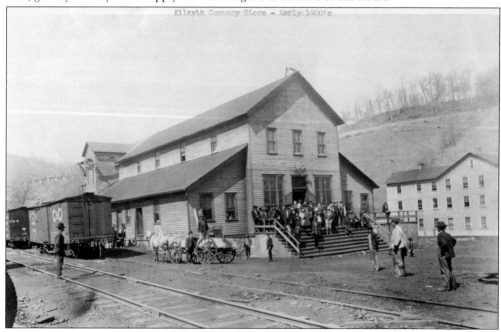

Mule teams load up for delivery in this early 1900s view of the Kilsyth Company Store, part of the McKell Coal and Coke operations. On the left side of the photograph, company housing is visible just above the roofs of the boxcars. McKell's holdings were sold to the New River Company after his death in 1939. (Courtesy Tim Richmond.)

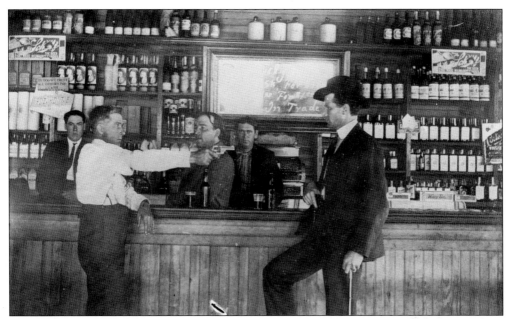

Dozens of saloons prospered in Glen Jean during the early 20th century. While one photograph (above) is clearly staged—one patron has his gun leveled on another who still has his pistol in his waistband—violence was prevalent in the coalfields. Heavy drinking and numerous watering holes in the gorge only added to the legends. Out-of-state newspapers ran articles on Thurmond and the Dunglen, "where a body washes ashore every day," fueling the fire and the stereotype that southern West Virginia was a lawless place. Other saloons appealed to the more visual and seductive interests, as can be seen by the revealing portraits above the bar.

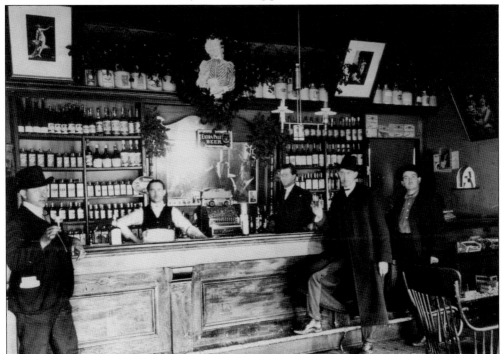

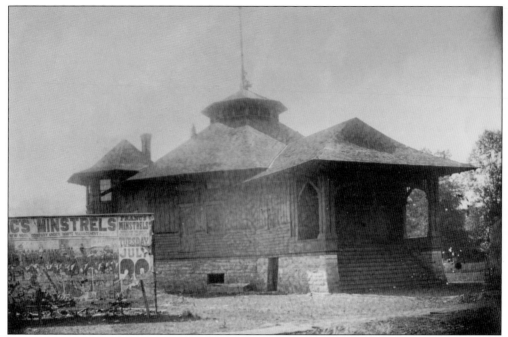

Glen Jean boasted a busy social life early in the last century. Activities ranged from baseball to the Silas Green Minstrels from New Orleans performing at the Glen Jean Opera House, built in 1896 by the McKell family. In 1870, Jean Dunn married Thomas McKell in Chillicothe, Ohio. Her dowry was 12,000 acres in Fayette County, West Virginia. The newlyweds visited several times and decided to purchase additional acreage and develop the area. When McKell first saw the glen, he turned to his new bride and said, "What a beautiful glen, Jean!" and the town was named. (Above, courtesy Tim Richmond; below, courtesy NPS.)

Baldwin-Felts detectives pose for a group photograph (above) on the steps of the Collins Colliery Company store. Private detectives were hired by coal companies to break labor strikes in the West Virginia coalfields. The integrated force served as a private police force throughout all of southern West Virginia during the first quarter of the 20th century. By 1920, civil unrest was widespread, and gorge miners marched to Logan County to join the Battle of Blair Mountain. Albert Felts (right) was the son of Thomas Felts, founder of the Baldwin-Felts Detective Agency. Albert once faced off with famed labor activist Mother Jones; she cussed him and dared him to shoot her, all the while telling him that she didn't believe he had the guts to do it. He let her pass. Albert was killed in the 1921 Matewan massacre.

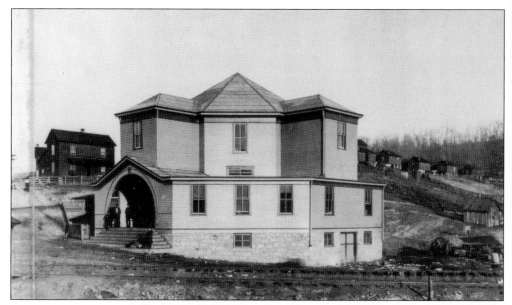

The Collins Colliery Company store at Glen Jean was the center of commerce in the coalfields. Eventually, five stores of this unique architectural style were built. One is still visible today in Whipple, West Virginia. The center of each store contained a square of glass counters. Merchants working inside the counter had the ability to hear every conversation in the store because of the acoustics created by the shape of the store.

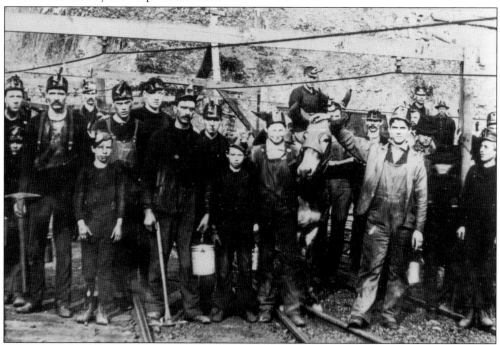

"McKell Mine Crew at Glen Jean" is only the center section of a panoramic image taken by Rufus "Red" Ribble. Ribble was hired by mine companies to photograph the crews. He traveled through coal towns from 1919 to 1957 with a Cirkut panoramic camera. The prints were up to 6 feet long and 10 inches high. Roughly 400 of his prints are known to still exist.

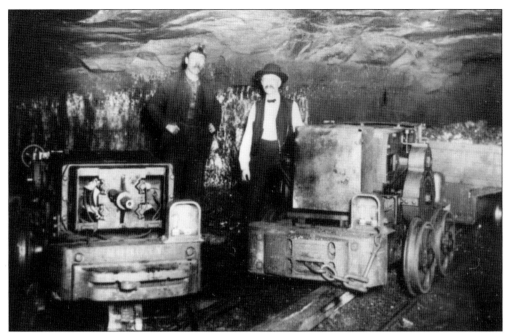

A Mr. Crawford (left) and Justice of the Peace Henry West pose in the Nichols Mine in Glen Jean. A rotary drill and a mine motor attached to coal cars seem to be the purpose for the photograph. The drill pierced the face of the coal so explosives could be placed. Prior to the dynamite being placed, coal was undercut at the very bottom (below). Undercutting gave it a place to fall rather than exploding outwards. The machine functions like a large chainsaw laid on its side. Dynamiting was often the final activity of the day. The next day, miners would often bring their young sons to work with them to help load the coal. At peak production, the McKell family mines each produced an average of 500 tons a day.

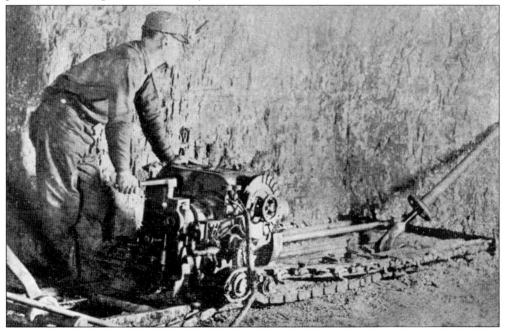

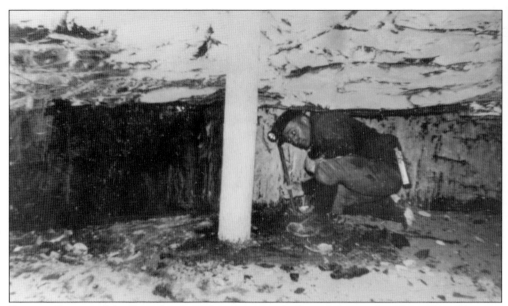

Foreman Burgess of the Dunedin Coal Company crawls through low coal in Terry, West Virginia, in 1938. The seam of coal is about 3 feet tall. Under these conditions, miners had to work on their hands and knees or lie sideways to cut out the coal. In the center of the photograph is a post used to support the roof. As the dampness rotted the timbers, a mine roof would collapse. Burgess wears an electric mining lamp; a battery pack is visible on his belt.

Jess Parrish was a fixture in the New River coalfields all his life. Parrish was the bookkeeper at the Red Star Company Store. In later years, he worked for Brown and Bigelow Promotional Products selling calendars and printed goods throughout the gorge. Jess had his lunch everyday at the Kelly Drug lunch counter in Oak Hill. He often shared anecdotes from his early life in the coalfields.

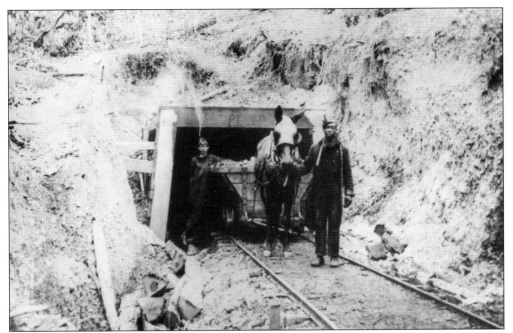

A mule driver, with his whip around his neck, emerges from the drift mouth of the Kilsyth mine with a load of coal in 1902. In the time it took to pose for the photograph, smoke is evident from the miner's oil lamp. Timbers to support the roof are visible on the left near the entrance to the mine.

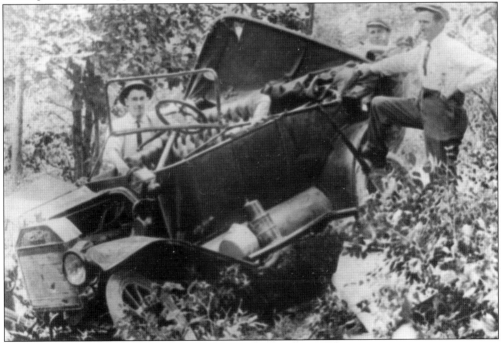

The first car, car wreck, and car accident photograph in Glen Jean was captured for posterity by photographer William Trevey. He and Dr. C. F. Calloway purchased the car jointly; the wreck occurred a few weeks after the purchase. There is no record of who was driving or if there were injuries. The few roads in the gorge were unimproved and treacherous, and most people traveled by train.

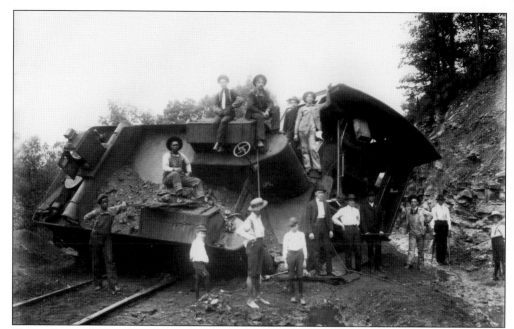

Trains also wrecked in the gorge, and even short railroads had their share of accidents. This disaster is on the KGJ&E between Thurmond and Mount Hope. Rail inspectors walked each track daily, but accidents still occurred. When asked about his KGJ&E railroad, Bill McKell boasted that it might not be as long as all the other railroads, but it was just as wide and made plenty of money. (Courtesy George Bragg.)

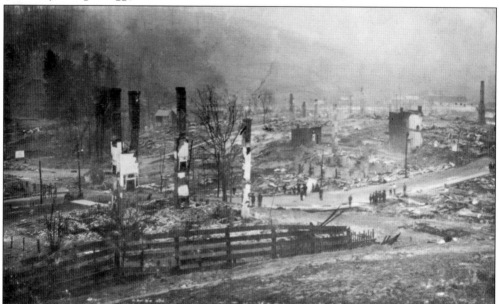

A postcard of a William Trevey photograph shows townspeople amidst the devastation of the March 1910 Mount Hope fire, supposedly started from a gasoline stove. National newspapers reported not only the destruction but also the resourcefulness, humanity, and tenacity of the townspeople. Within hours, the clearing and rebuilding effort began. In less then two years, a more modern town with larger, fire-resistant stone and brick structures rose from the ashes.

Six

THAYER TO HINTON

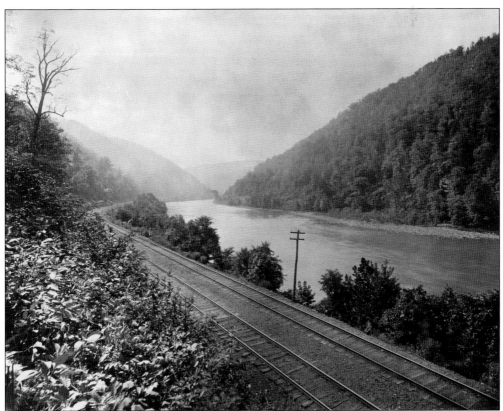

This photograph was taken above Thurmond near milepost 390 looking toward the town of Thayer in 1889. The mileposts mark the distance from the original C&O rail line in Newport News, Virginia. Dual tracks allowed freight trains to pass each other without having to wait on a siding. A telegraph pole and line sit between the tracks and the river. (Photograph by J. K. Hillers, courtesy USGS.)

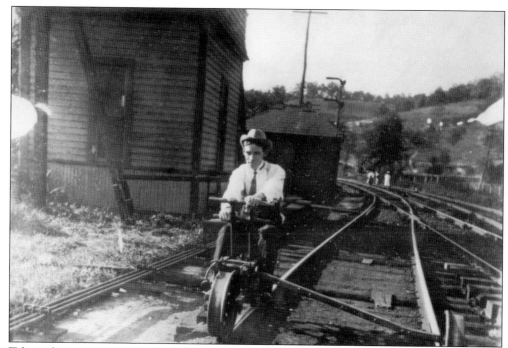

Telegraph operator Andrew Rush Ford rides a hand-operated rail cycle in Prince, West Virginia, in 1916 (above). Hand-operated rail cycles were used by telegraph employees to check wire along the tracks or assess track conditions. Large handcars were available for local transportation and work gangs. Stations often had a short siding to park the handcar so it would be out of the way of railroad equipment. Four men in suits ride a handcar from Thurmond to Stone Cliff around 1894 (below). (Above, courtesy NPS; below, photograph by J. K. Hillers, courtesy USGS.)

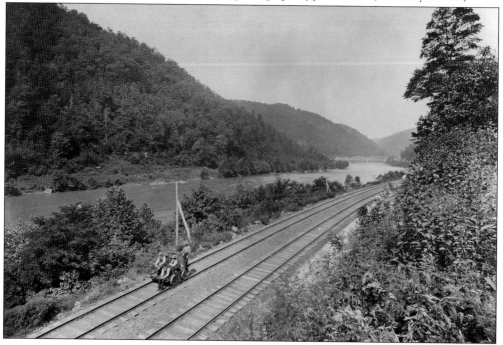

The McKendree Miners Hospital No. 2 was a full-service medical facility focused mainly on railroad and mine injuries. The hospital kept a detailed log with each patient's name and infirmity. Americans or others who spoke English were recorded by name. Italians and others who spoke little or no English were recorded by their ethnicity and numbered, "Italian #1," "Italian #2," and so on. In the rear of the hospital was a therapeutic recuperative garden. All that remains of McKendree Miners Hospital No. 2 are the annually blooming daffodils framing the edges of the old sidewalks. Nell Gwinn Wriston was a graduate of the McKendree Miners Hospital Nursing School and became its last director of nursing. She sits on an overlook across the track, between the hospital and the river.

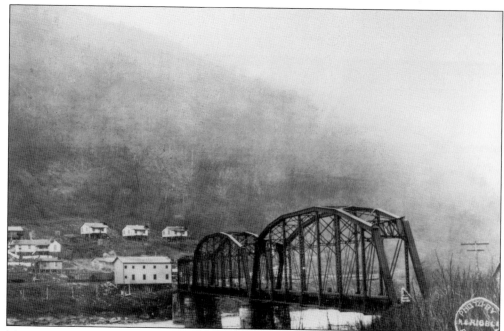

Most New River mines were located in Fayette County. Royal, West Virginia, became the site of the first operational mine along the gorge in Raleigh County. This view of the town in April 1920 shows the town's theater and dance hall building at the left side of the far end of the trestle. Three houses above the theater were homes to black miners. In the 1930s, a toll highway bridge was built next to the railway bridge.

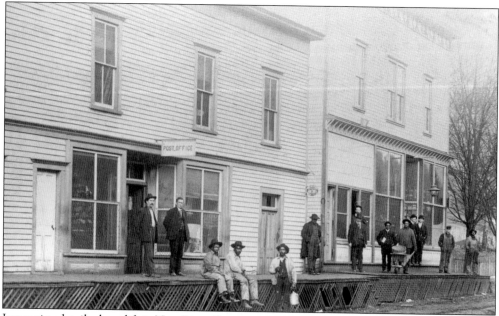

Interesting details about life in New River Gorge can be seen in this early-20th-century photograph of Prince General Store and Post Office, including a chicken wire–type mesh "security system" nailed to the bottom of the post office windows. Jim Wesley (center) carries a traditional jug used for holding anything from molasses to moonshine.

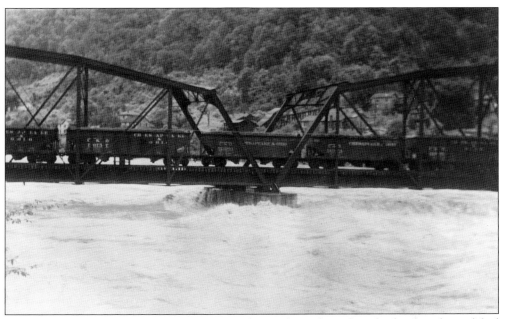

In the flood of 1940, railcars sit on Prince Bridge. To keep the railway bridge from being lifted off its abutments, it was common practice to roll loaded cars onto the bridge to weight it down. Royal is in the background. (Courtesy Tim Richardson.)

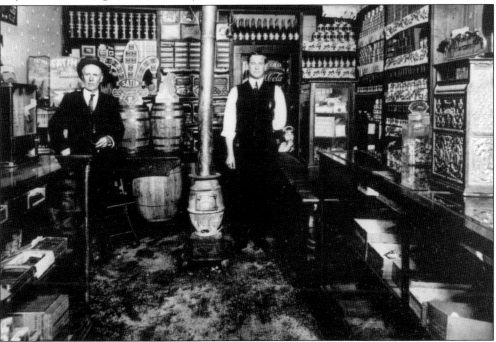

In Sandstone General Store, a young girl shyly pops her head the around right corner of the counter as the picture is snapped. The area now known as Sandstone was first known as New Richmond, after William Richmond, who migrated to the area after the War of 1812. The name was changed to Sandstone when rock from a nearby quarry was used to represent West Virginia in the construction of the Washington monument.

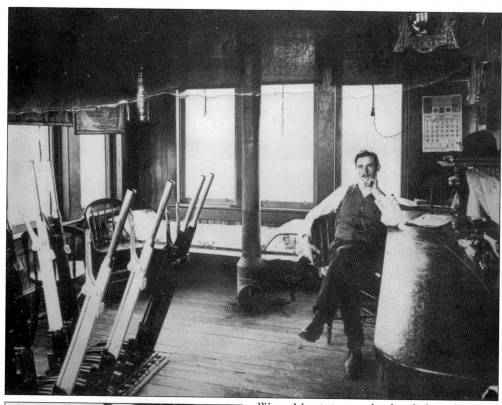

Wyatt Morris is seated at his desk in the Hinton telegraph office. The operator's cot is snuggled between the window and a small coal heater. The office gave the operator a view of the railroad yard and tracks. The large levers controlled switches on the track in the train yard. By pulling the levers, the operator could switch trains from one track to another.

After Earl Halloran crashed his airplane on Sunset Hill, Harvey Hobbs and another man bought the plane engine, mounted it on their bateau, and rode up and down the river until it wrecked and sank in the steamboat shoot near Hinton when Hobbs, Cypress Terry, and others "got drunk one Sunday morning, knocked a hole in the bottom of the boat and it sank."

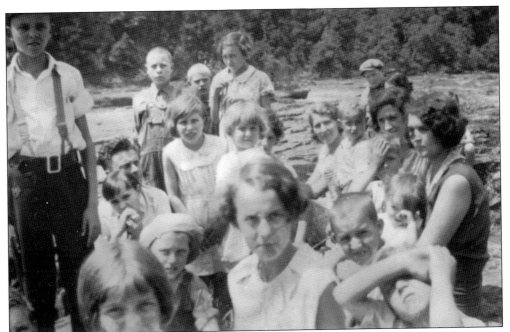

The Spicer family and friend Fay Chandler enjoy a Sunday afternoon outing in 1930s at Long Bottom, West Virginia. From the left to right (front) are Adrian Spicer and Glendale Spicer. On the far right is Gray Spicer. Fay Chandler is on the right with her hand to her face. The outing may have been associated with a church service.

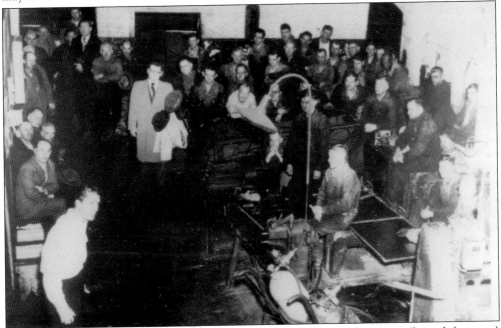

Preaching services were not confined to churches. In 1949, Rev. Eddie Martin (lower left corner) holds a service in the old C&O machine shop in Hinton; workers stand and sit on equipment to listen to the sermon. Also present in the crowd are YMCA director Mr. Harris (seated directly above Reverend Martin on the lower left), Rev. H. U. Thompson, and Rev. Billy Apostolon.

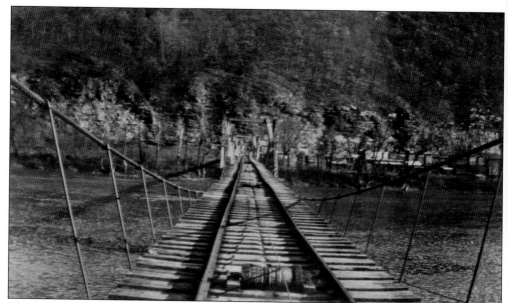

This is the suspension bridge at Long Bottom Lumber Company Sawmill. The company utilized the cable and pulley system (in the center foreground) to pull wooden railcars across the river to waiting railroad cars.

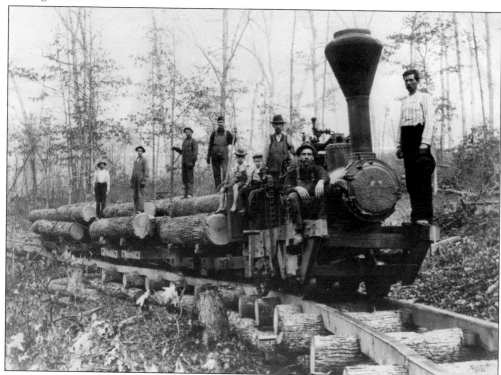

Timber was an important product on the New River. Loggers constructed tram roads out of logs they felled and used the wooden road to transport logs to depots at the bottom of the gorge. Once logged, the large flat area on top of the mountain became home to vegetable gardens for the residents of mining camps, earning the area the name Garden Ground. (Courtesy Tim Richmond.)

A 35-ton Class B Climax engine is ferried across the river to the New River Lumber Company at Long Bottom, West Virginia, in 1927, while still making steam. The engine was a second-generation logging engine and weighed 35 tons. Early engines had ribbed steel wheels to negotiate the wooden rails often used in logging operations.

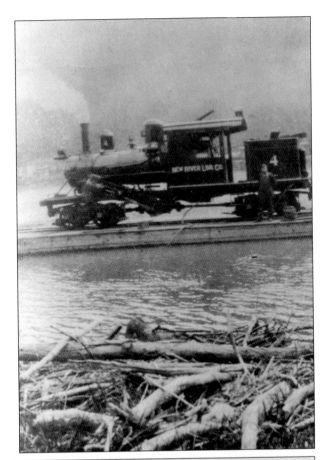

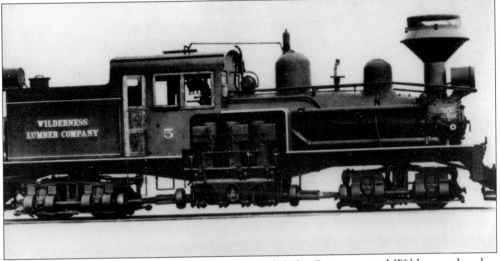

A technical photograph of the Babcock Coal and Coke Company and Wilderness Lumber Company engine provides a better view of the drive system of Class B Climax engine. Lumber trains were designed with differential gear-driven wheels and cylinders arranged in a horizontal position, because the gears on the wheels provided the ability to climb steep grades and navigate narrow-radius turns.

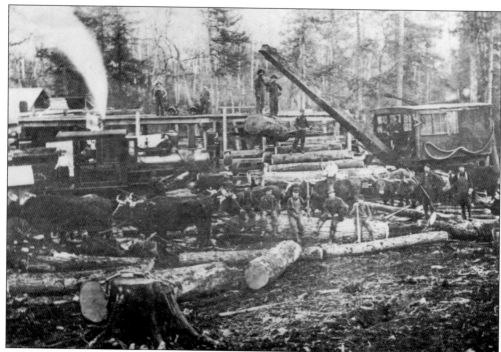

Logging workers pose at the Sewell Lumber Company around 1910 in Landisburg, West Virginia. Oxen skidded the logs into the mill, where they were lifted by steam cranes and laid on carriages that transported them into the sawmill. As the photograph is snapped, the engineer of the logging train on the left blows his whistle, as if to say "Cheese."

Steam-operated logging engines required great amounts of water. Charlie Garrett (left) and Bill Bragg load water into their steam-logging engine at the sawmill of the New River Logging Company in Long Bottom in the early 1930s.

Seven

OAK HILL TO FAYETTEVILLE

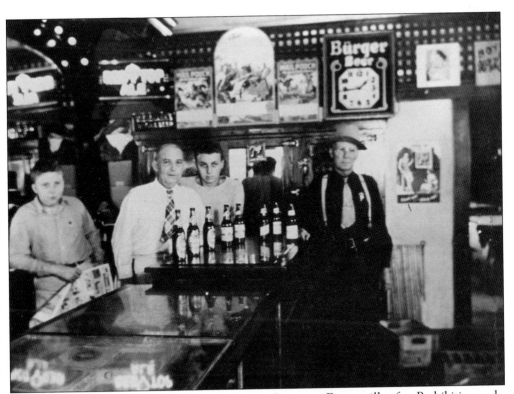

In the 20th Century Club at Wiseman and Court Streets in Fayetteville after Prohibition ends, Billy Blume (left) appears take a break from the comic section of the paper to pose for a picture with, from left to right, his father E. G. Blume, brother Ed Blume, and Sheriff Ballard. (Courtesy Sharon Cruikshank.)

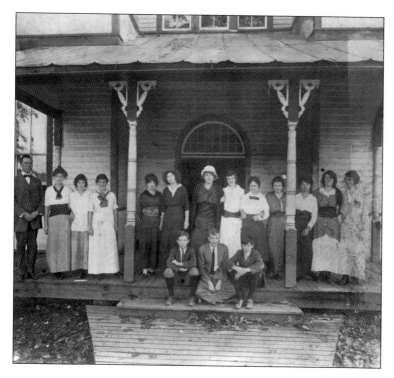

Mary Thelma Bennett stands second from left next to her instructor at the Fayetteville Academy. The school burned down in the early 1920s. Fayette High School was built to replace it. Academy Court, where the school was located, still bears its name. (Courtesy Sharon Cruikshank.)

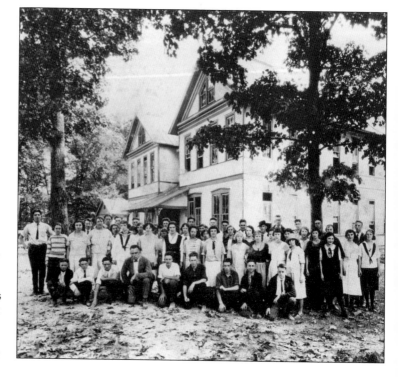

Students and faculty pose for a photograph in front of the Fayetteville Academy. Judge Bennett's daughter, Mary Thelma Bennett, attended school there and is said to be the girl standing in the third row, behind the kneeling boy third from the right. She is wearing a white shirt and a dark-colored jacket. (Courtesy Sharon Cruikshank.)

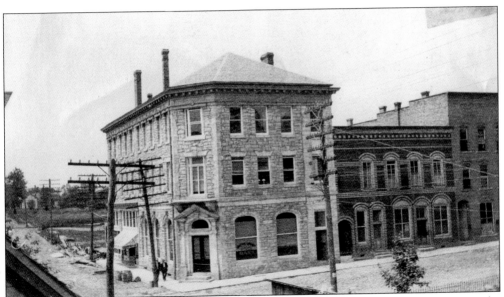

Often cited as the model for the Bank of Glen Jean, the Fayette County National Bank sits at the corner of Court Street and Main Street, Fayetteville. The lot behind the bank was selected as the site of Fayetteville's new post office, built in 1939 by the WPA. The post office houses an original mural of *The Miners*, an oil painting on canvas by Nixford Baldwin. (Courtesy of Sharon Cruikshank.)

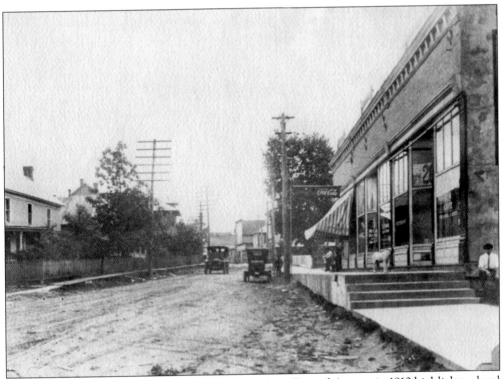

A view up Main Street in Oak Hill, West Virginia, from Central Avenue in 1912 highlights a local landmark, the sidewalk steps on the lower right of the photograph. These steps are still present today and often noted when giving directions. (Courtesy Sharon Cruikshank.)

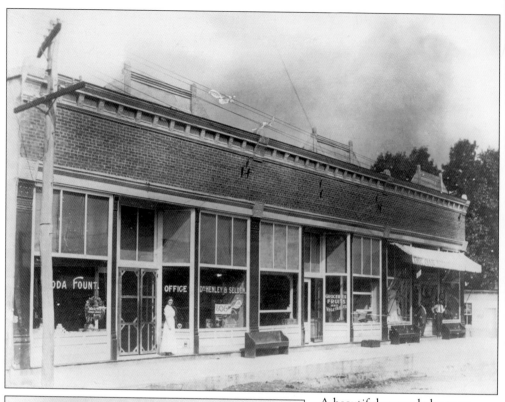

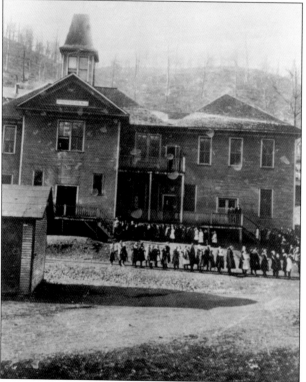

A beautiful young lady stares the camera down outside a soda fountain at the corner of Main Street and Central Avenue in Oak Hill. Her dress marks the period as around 1900. Two unidentified men stand outside a dress store or mercantile at the end of the row of stores. (Courtesy Tim Richmond.)

Students line up before class on a cold winter day outside the Minden School. A dusting of snow from light flurries frosts the roof. Some children are dressed in overcoats, while others hug themselves to stay warm. Coal baron Paddy Rend opened the mine and mining town of Minden in 1899. The town was named Rend at that time. (Courtesy Tim Richmond.)

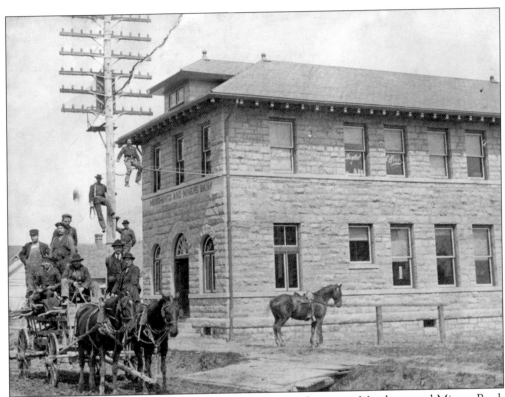

Utility workers pose for photograph on the power pole adjacent to Merchant and Miners Bank in Oak Hill, West Virginia, as the first telephone line in Oak Hill is installed. The building was a multiuse facility, with Duncan Dental Office located upstairs. (Courtesy Tim Richmond.)

The caption on the back of this photograph reads "T. J. Hooper residence." T. J. was the head teller at Merchant and Miners Bank. His home was built next door to the bank, providing a very short commute. (Courtesy Tim Richmond.)

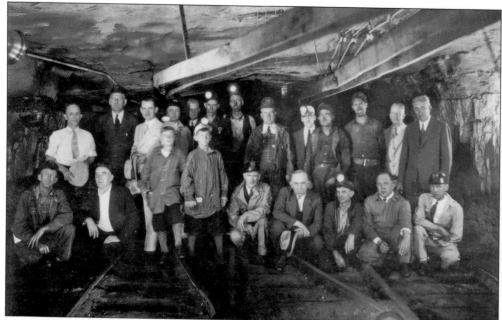

Lowell Thomas made the first underground broadcast from the bottom of Whipple mineshaft on May 31, 1934. Thomas, a famous radio broadcaster of the day, is standing in the white suit. His son, Lowell Jr., and a friend are in the front row. Mine executives, railroad workers, and local dignitaries joined to commemorate the event. Mine suppliers Post-Glover of Cincinnati, Ohio, sponsored the broadcast. (Courtesy Jane Burke.)

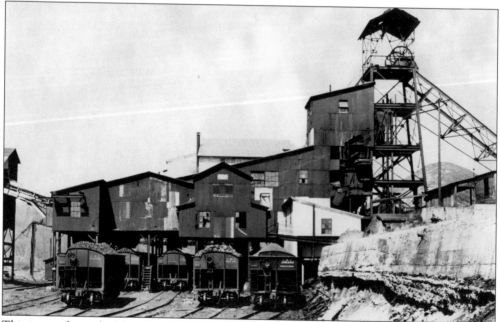

This image shows the New River Company tipple at Summerlee, West Virginia. The New River Company was a consolidation of several small companies in 1906 and from 1910 to 1920 replaced its wooden tipples with modern steel ones. In 1939, the company purchased the McKell Coal and Coke Company to become the area's largest coal producer. (Courtesy Jane Burke.)

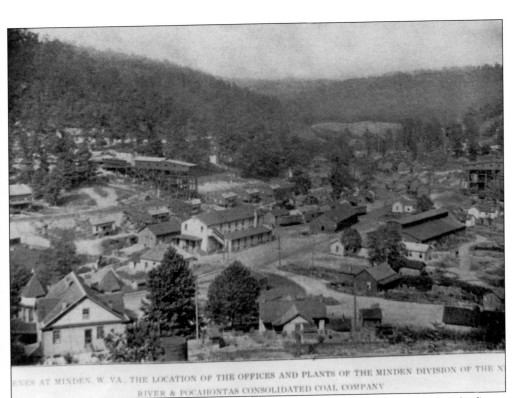

A page from the C&O Railroad's *Official Industrial and Shippers Guide of 1906* provides a bird's-eye view of Minden, West Virginia. Berwind mined coal under the name New River and Pocahontas Consolidated Coal Company. The mines at Minden were some of the most productive in the New River Field, particularly Mines Nos. 2, 3, and 4.

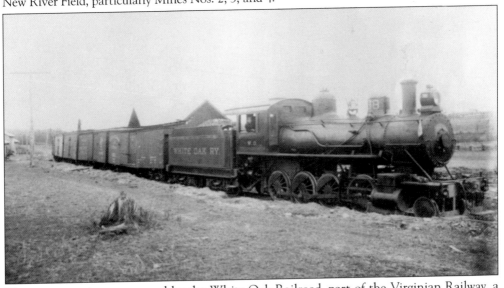

This steam engine was owned by the White Oak Railroad, part of the Virginian Railway, a competitor to the C&O. Local promoter Col. William Page partnered with Henry Rogers of Standard Oil to build another competitive railroad, shipping New River coal to port in Hampton Roads, Virginia. The engine is currently being restored at the White Oak depot in Oak Hill.

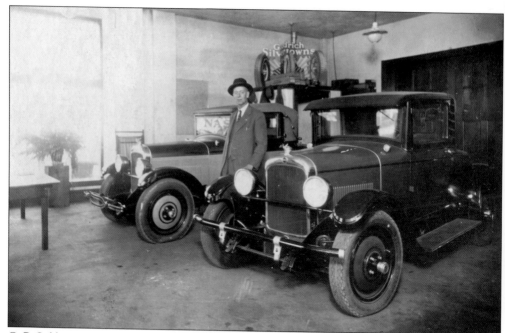

C. P. Cobb operated the Oak Hill Nash Garage (a dealership) in the early 1920s. Nash Motors was founded in 1916 and located in Kenosha, Wisconsin. Nash's success can be credited to engineer Nils Erik Wahlberg. Wahlberg's innovate designs included seat belts as early as 1938. The garage later became the Woolworth building, and, in the 21st century, Bessie's Floral. (Courtesy Tim Richmond.)

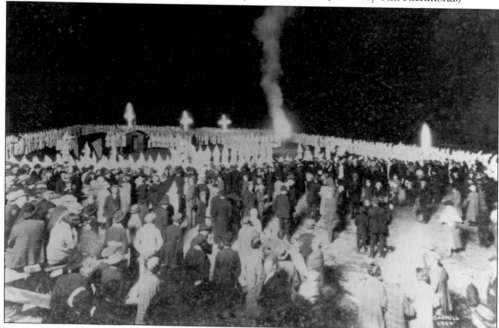

In 1924, the Ku Klux Klan held a rally in Oak Hill, West Virginia. By the 1920s, the Klan was concerned about the rising numbers of Roman Catholic immigrants in the area. Immigrants were brought in to break the unions by working in mines during strikes. Local children addressing them by name after recognizing their horses often upset Klansmen. (Courtesy Tim Richmond.)

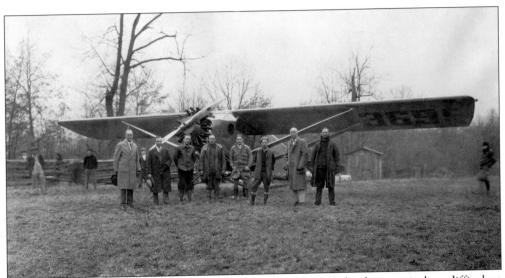

The rugged terrain of mountainous southern West Virginia made landing an airplane difficult at best. Local farms along the plateau provided flat, open expanses for the adventurous pilots of the budding industry of flight to take off and land. Oak Hill's most famous emergency landing was by U.S. Army bombers headed to the Battle of Blair Mountain in 1921 to bomb striking miners. (Courtesy Tim Richmond.)

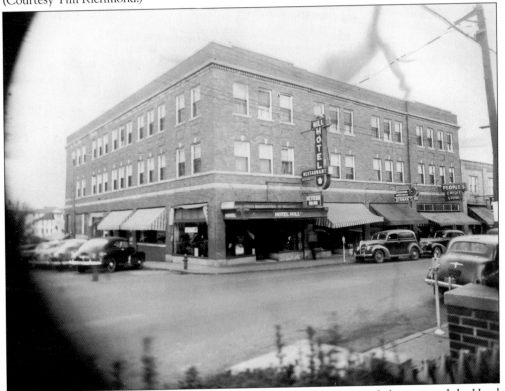

The Hill family was a prominent banking family in the Oak Hill area and also operated the Hotel Hill on the corner of Main Street and Kelly Avenue. By the 21st century, the building had gained a new lease on life as apartments and office space.

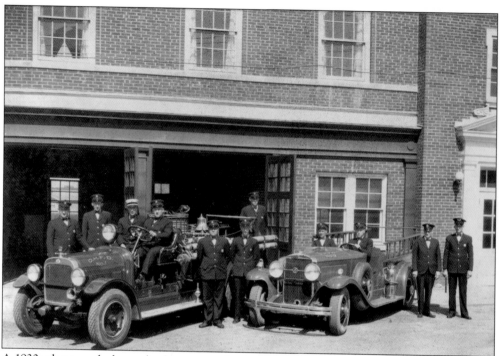

A 1930s photograph shows the fire crew at the Oak Hill Fire Department on Kelly Avenue with their first engine, OHFD No. 1. The engine is a 1929 model. The service truck on the right is a converted pickup truck. Future chief Cy Harvey sits at the wheel of the fire engine, and standing on the far right are Chief Bleu (second from the right) and an unidentified police officer.

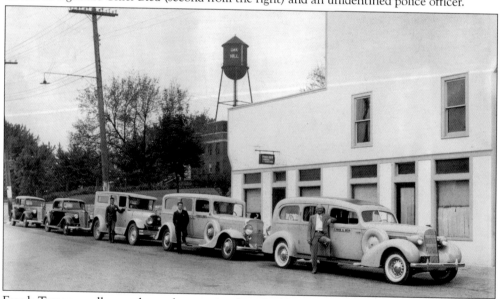

Frank Tyree proudly stands on the running board of his new side-loading hearse outside the Tyree-Dew Funeral Home in Oak Hill, West Virginia. The new hearse was the first of its kind in the state. The Oak Hill Hospital was next door, and as Frank would visit with patients in the hospital, small children would be scared he was coming to pick them up for their funerals. (Courtesy Tim Richmond.)

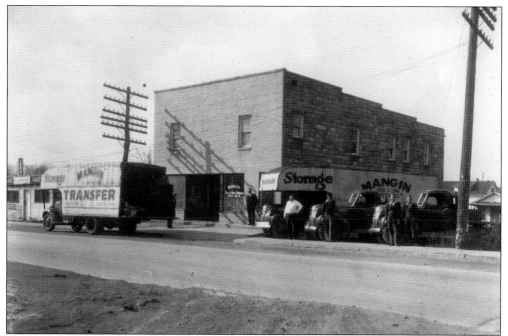

A promotional photograph shows the trucks and equipment of the Mangin Moving and Storage in Oak Hill, West Virginia. As the area prospered, people and material moved around the gorge from town to town. Most coal camps were not built to last, and after the coal played out, people moved on to the next camp. (Courtesy Tim Richmond.)

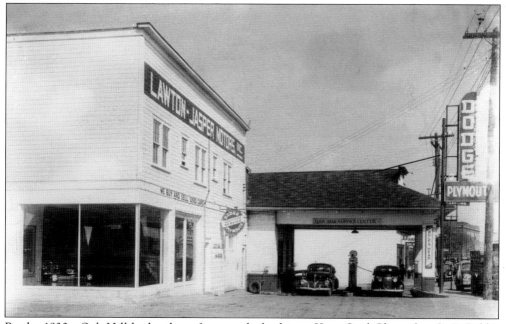

By the 1930s, Oak Hill had at least four car dealerships—King Coal Chevrolet, C. P. Cobb's Nash Garage, the Anderson Motor Company selling Hupmobiles, and Lawton-Jasper Motors, Inc., selling Dodge and Plymouth. King Coal Chevrolet still operates in Oak Hill. (Courtesy Tim Richardson.)

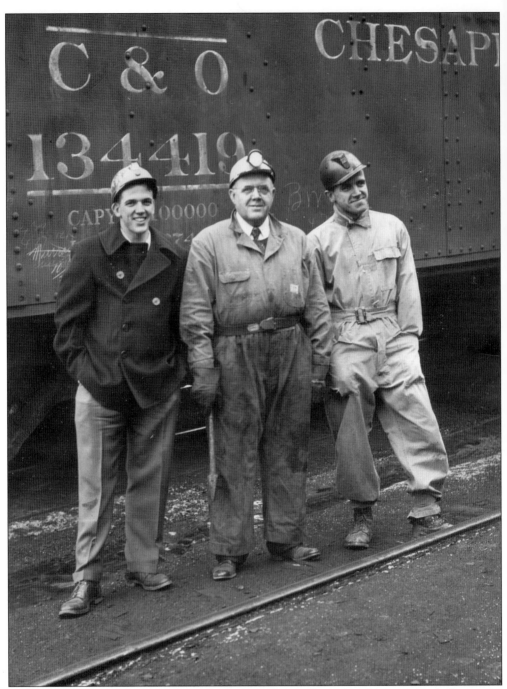

From left to right, Fred Scott Nicholls, Richard Paul Nicholls, and Paul Murray Nicholls pose for a family portrait outside the Oakwood Tipple on Thanksgiving Day, 1947. Both the mine and the tipple closed in 1965. In 1915, twenty-one miners died in the mine. Since it was not uncommon to rename a town following a bad accident or explosion, Oakwood became Carlisle, after a town in Scotland. (Courtesy Jane Burke.)

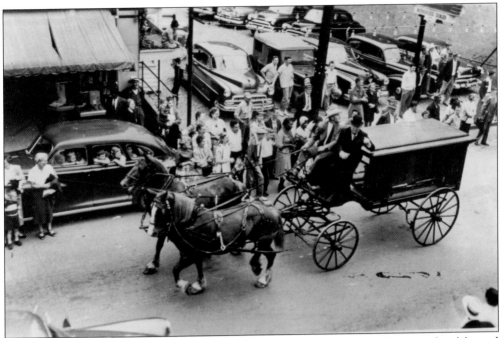

A horse-drawn hearse participates in a parade in Oak Hill in 1953. Frank Thomas, a local funeral home director, rides in his derby alongside the driver. The horse team and driver were lent for the parade by the Jones family's Lundale farms. The hearse was on loan from the Lobban Funeral Home in Alderson. (Courtesy Tim Richardson.)

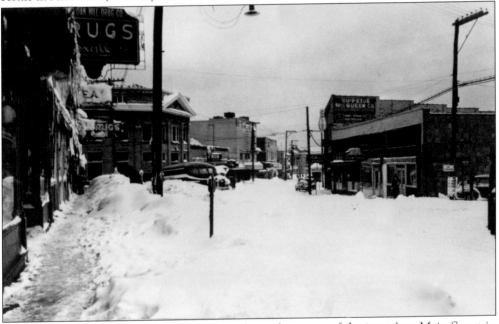

After the 1942 snowstorm, a bus is snowed in (near the center of the image) on Main Street in Oak Hill. The modern Kelly Drug Store sports a neon sign out front. The family later moved to Washington, D.C. On the right side of Main Street is the New River Supply, which hosted a bowling alley in its basement. (Courtesy Tim Richmond.)

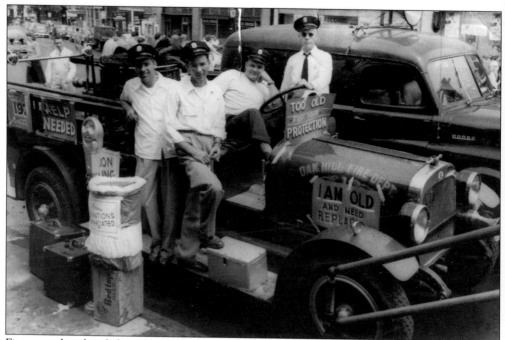

Firemen take a break from fund-raising to pose with their 1929 model fire truck. The 1929 model is "Too Old For Your Protection," according to the sign on the hood, and donations are being collected for a new truck. The log-style lettering used on the original truck has been carried over to each new fire truck and has become a tradition of the Oak Hill Fire Department. (Courtesy Tim Richardson.)

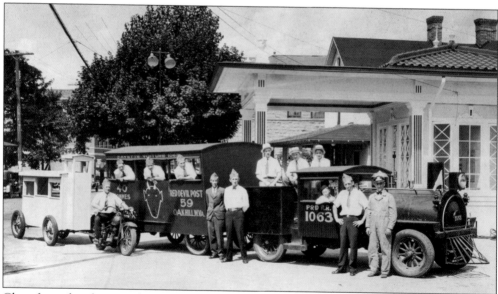

Clues from the photograph "Fayette Voiture 1063" suggest that the celebration is in honor of Fayette County's namesake, the Marquis de Lafayette. Little is known about the participants in this 1920s image except they certainly invested a lot of effort into their parade float. The motorcyclist is pulling a parade float too. The service station was later replaced by A&P store. (Courtesy Tim Richardson.)

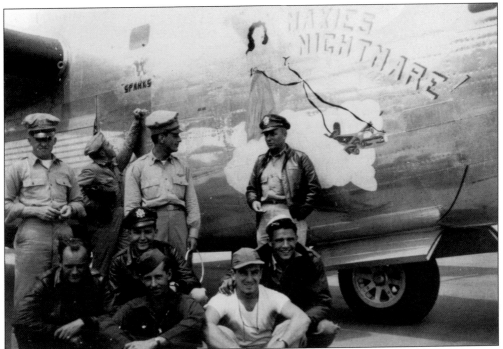

Fayetteville's Edward Bennett commanded the B-25 Liberator *Maxie's Nightmare!* over Germany during World War II. The plane was named for Ed's wife, Maxine. Bennett was shot down and killed over Germany on February 1, 1945, and is buried in the Cambridge American Cemetery in Cambridge, England. (Courtesy Sharon Cruikshank.)

When the army was looking for rough terrain and harsh climate to practice bridge building during the Korean Conflict, it looked no farther than the New River below Prince. The swift current and steep topography provided realistic training conditions, and the area remains known as Army Camp.

It was near this crossroads in Glen Jean on January 1, 1953, that Hank Williams's driver noticed his passenger was unconscious and would not wake up as he drove toward Oak Hill. The driver stopped at Skyline Pizza and found Hank unresponsive. He then drove to the Oak Hill Hospital, where Williams was pronounced dead. Copies of Hank's death certificate remain the most requested document from the Fayette County courthouse.

By 1966, Main Street Oak Hill had come along way from dirt roads and Model Ts. Tony Perkin's Corvair is parked outside Aide's Shoes, up the street from the G. C. Murphy's. Dr. Ivan and Betty Bush's 1966 Pontiac GTO sits behind two Mercurys in front of Woolworth's. New River Banking and Trust and Kelly Drug are still visible 30 years after their move from Thurmond. (Courtesy Tim Richardson.)

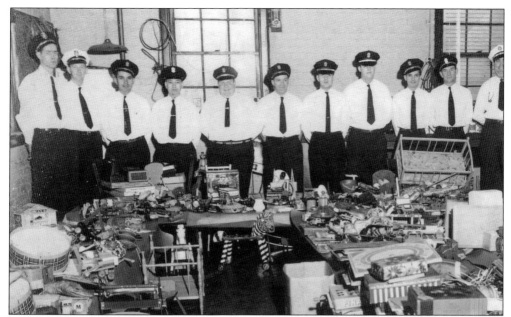

Each year, the Oak Hill Fire Department gathered used and broken toys, fixed them, and provided them to less fortunate children. Department members are, from left to right, Uel James, Red Whitlock, Paul Snead, Delbert Snead, Pete Taylor, Johny Ferri, Bob Via, ? Thomas, ? Rakes, Kenny Carol, and unidentified. (Courtesy Tim Richardson.)

The Oak Hill Rotary Club poses at the Memorial Day service at the Highlawn Cemetery on May 30, 1967. Members are, from left to right, Paul Bavely, Herb Martin, Ferris Aide, Walter Browne, Buddy Hill (president), Judge C. L. Gavin (speaker), Rev. Randolph Johnson, Wallace Bennett (secretary), Rev. Shirley Donnelly, J. P. Aliff, Eugene Larrick, and Charles Garvin Jr. Walter Brown's company provided the truck to serve as the dais for the event. (Courtesy Tim Richardson.)

Pres. Harry S. Truman (second from right) sits on the patio of the White Oak County Club in Oak Hill with, from left to right, unidentified, Ferris Aide, Harrison Ash, and Gov. Okey Patterson. An avid fisherman, Truman frequented the New River and was attending the grand opening of Wonderland, a fishing resort near Minden. Harrison Ash was a relative of Thurmond's famous police chief. (Photograph by Frank Mauritz, courtesy Tim Richmond.)

Campaigning in Oak Hill, John F. Kennedy meets (from left to right) Mayor Keatley, Sam Price, Ferris Aide, and Mrs. Sam Price. It was after campaigning in West Virginia that Joe Kennedy told his son, "Don't buy a single vote more than is necessary. I'll help you win this election, but I'll be damned if I'm going to pay for a landslide!" (Photograph by Frank Mauritz, courtesy Tim Richmond.)

An unidentified man trout-fishes in waders at a pool in Wolf Creek above Fayette Station. While the New River is a warm-water river beginning in Blowing Rock, North Carolina, the cold-water streams that flow from the mountains compliment the warm river, providing a full fishing experience for sportsmen—smallmouth bass and trout in the same day.

For rafting purposes, the New River is divided into three sections—the Upper, the Middle, and the Lower. The river boasts Class I to IV rapids, making rafting appropriate for all levels. The whitewater gets increasingly difficult farther downstream. The last section is known as Fayette Station Rapid, under the New River Gorge Bridge. (Courtesy Tom Dragan.)

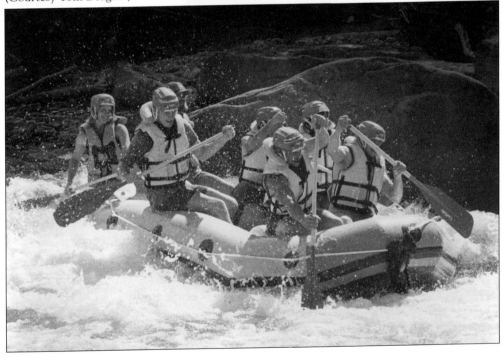

Jon Dragan founded Wildwater Unlimited in Thurmond, West Virginia, in 1969. Dragan began with army surplus rafts, a far cry from the old mattresses adventurous boys rode through the rapids more than a century ago. Today's ride traverses 15 miles from Thurmond to Fayette Station. Noticeable in the center of the picture is the most important item in the raft, the lunch bucket. (Courtesy Tom Dragan.)

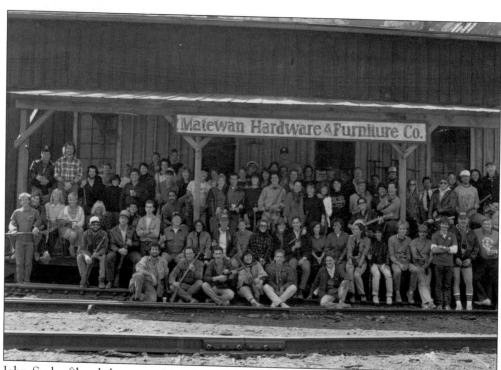

John Sayles filmed the movie *Matewan* in Thurmond. The two towns were very similar, and Thurmond needed very little effort to transform it into the set for the movie portraying the violence and harsh conditions leading up to the May 1920 Matewan massacre. Many locals worked as extras on the film. (Courtesy Tim Richmond.)

Eight

NEW RIVER
GORGE BRIDGE

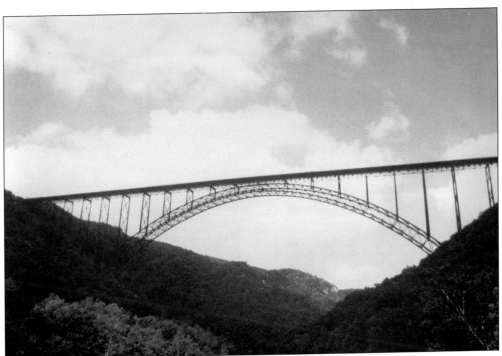

The New River Gorge Bridge has become the symbol of West Virginia. Chosen to appear on the state's commemorative quarter, it is known throughout the world for BASE (short for bridges, antennae, spans, and earth) jumping. The bridge also symbolizes the merging of ecology, economy, efficiency, and aesthetics that make it such a treasured part of the landscape. It is so unobtrusive that many visitors have to ask where it is located. (Photograph by David Bowen, courtesy WVDOH.)

The two metal frame towers in the center of the photograph support the south side of the cableway constructed to build the New River Gorge Bridge. Traversing 36 feet each from left to right to accommodate the deliveries, steel cables were strung across the gorge to deliver trusses, steel supports, and supplies to the center of the gorge during construction. (Photograph by David Bowen, courtesy WVDOH.)

The cableway enabled construction teams to assemble sections of the bridge at the edge of the gorge, a much safer location than 876 feet above the New River. Each cableway could individually lift 50 tons of material. The efficiency of the system and preassembly process allowed precise piecing together and reduced costs by 40 percent. (Photograph by David Bowen, courtesy WVDOH.)

Workers place the base of the arch that will anchor the bridge to its foundation. This pivot allows the arch to shift as it expands and contracts due to changes in the climate or sunshine. About 17,000 cubic yards of concrete were used in the pier foundations to anchor the bridge. The piers were built while sections of the span were being fabricated in Pennsylvania and Indiana. Since the bridge was being built above abandoned mines, it was important that no piers rested on old mineshafts. The main arch footers sat below mine level, but piers four, five, and 20 were situated on the old Kaymoor No. 2 mineshafts. To provide secure footing for the piers, the mineshafts were bored out and filled with gravel and grout. (Both photographs by David Bowen, courtesy WVDOH.)

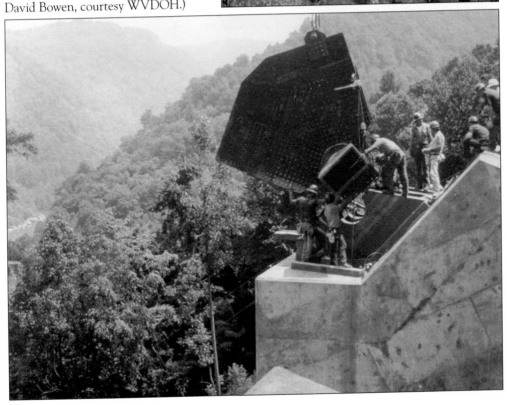

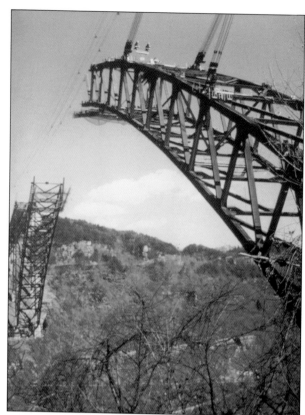

The cableway, tieback system, and safety net are visible in this photograph as the two halves of the arch grow toward each other from the north and south ends of the gorge. To save time and speed construction, the arches were built simultaneously. No deaths were recorded during the steel erection. One person died during pier construction. (Photograph by David Bowen, courtesy WVDOH.)

The new tieback support cable is firmly in place as the old cable slacks. A safety net is being relocated to the end of the arch, supported by trolleys on the tramway. Ever-present on the job, the safety net and personal harness systems protect workers from the treacherous heights above the gorge. (Photograph by David Bowen, courtesy WVDOH.)

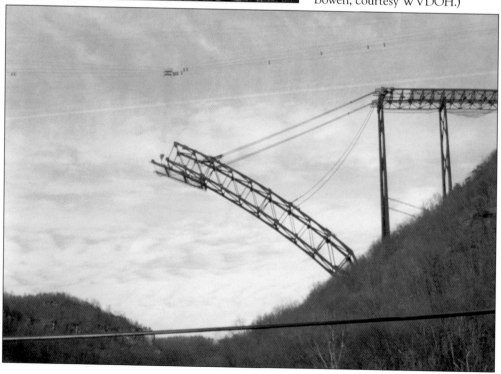

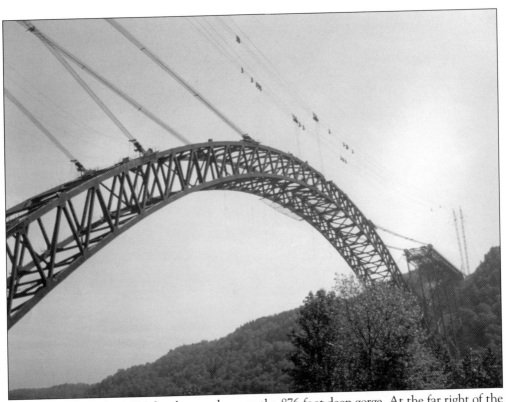

Nearly complete, the 1,700-foot-long arch spans the 876-foot-deep gorge. At the far right of the photograph, the tramway cable system towers are visible, as is the tieback support system, now attached at several key locations. It appears the final girder has yet to be placed in the upper center of the bridge. (Photograph by David Bowen, courtesy WVDOH.)

An American flag flies proudly on the final Cor-Ten steel girder as the tramway carries it to its final location. Numerous trolleys carried small pieces back and forth and operated as a block and tackle to position each piece. For large pieces, the trolleys could be combined and work in unison. As the tramway lowered the final girder gently into place, the tieback system still carried the full weight of the arch. (Photograph by David Bowen, courtesy WVDOH.)

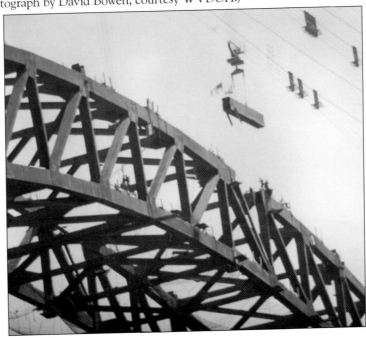

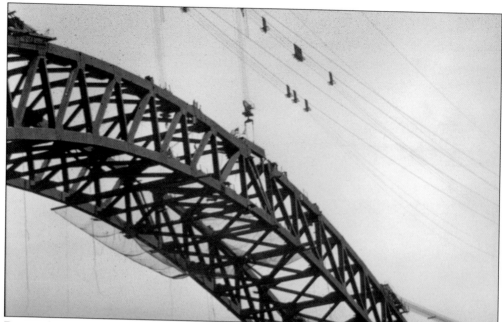

During the heat of each day, the steel of the two arches would expand and shorten the opening. When it came time to install the final piece, it would not fit. An ironworker remained on the span until after sundown when the bridge had cooled, and he was able to seat the girder and bolt it into place. (Photograph by David Bowen, courtesy WVDOH.)

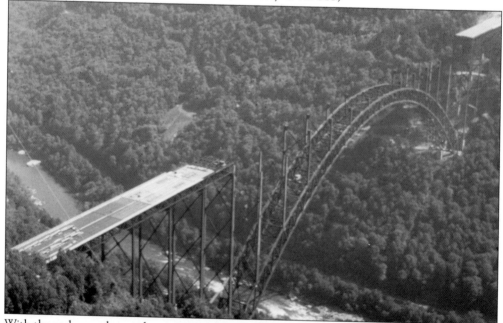

With the arch complete and supports in place, the New River Gorge Bridge is nearly ready for the decking to carry the concrete roadway. Decking support trusses are moving simultaneously toward the center of the arch from both sides of the gorge. The trusses had to be placed symmetrically on each side of the bridge to even the load and prevent damage to the structure through uneven weight distribution. (Photograph by David Bowen, courtesy WVDOH.)

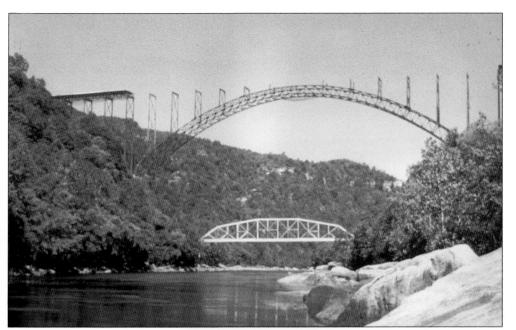

The New River Gorge Bridge and the 1911 Fayette Station Bridge were both significant American Bridge Company projects. In 1911, the first federally funded road improvement project began in West Virginia when a 1.5-mile stretch of concrete highway was poured. By World War II, West Virginia boasted 15,500 miles of paved roads. (Photograph by David Bowen, courtesy WVDOH.)

Originally, the bridge was deiced with traditional road salt, resulting in premature deterioration of the bolts holding the structure together. Today the bridge and its approach roads are deiced with calcium magnesium acetate (CMA), melting snow and ice by lowering the freezing point to about 23 degrees Fahrenheit. (Photograph by David Bowen, courtesy WVDOH.)

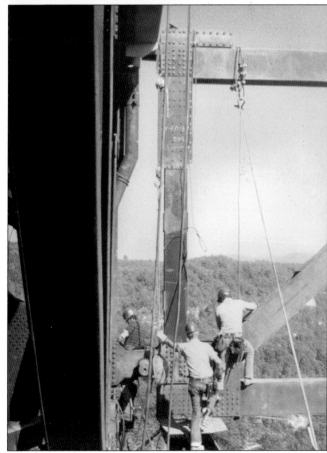

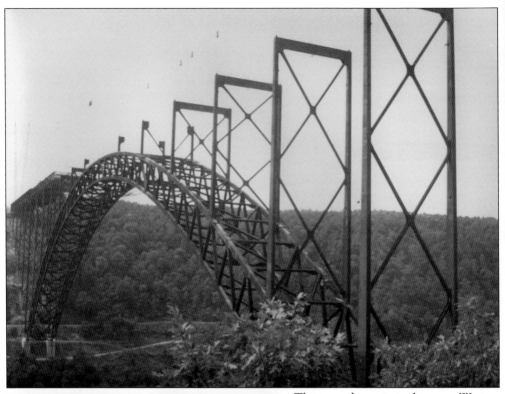

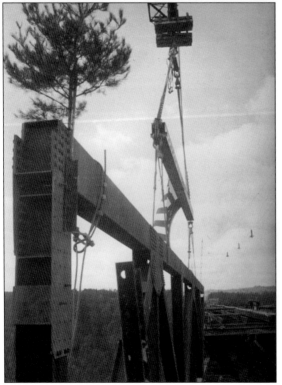

The rugged terrain and narrow West Virginia roads presented several logistical challenges for American Bridge Company. The structure was fabricated and assembled in Pennsylvania and Indiana. Parts were disassembled and shipped to a railway yard 19 miles from the construction site. Large parts were fitted with wheels and trucked up the narrow, winding county roads to the canyon rim. (Photograph by David Bowen, courtesy WVDOH.)

Keeping with tradition, the final truss sports an evergreen. Topping out is a cherished ironworker custom signifying that the uppermost steel component is going into place, and the structure has reached its height. The American flag is a symbol of the ironworkers' loyalty to their union, their flag, and their country. (Photograph by David Bowen, courtesy WVDOH.)

Nearly 5,000 feet of cable stretched across the gorge to form the cableway. Weighted down to avoid swaying, a one-inch thick cable was ferried across by helicopter and then used to pull increasingly thicker cables across the gorge. A final three-inch cable was used during construction to transport bridge sections to their designated locations. (Photograph by David Bowen, courtesy WVDOH.)

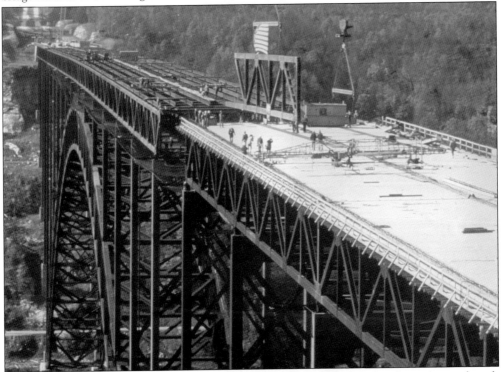

The arch is complete, piers are in place, and work on the road decking has begun, even though the final truss has yet to be placed. The future highway is visible in the background. Before completion of the bridge, locals said, "it took 45 minutes to cross the New River, now it takes just 45 seconds." (Photograph by David Bowen, courtesy WVDOH.)

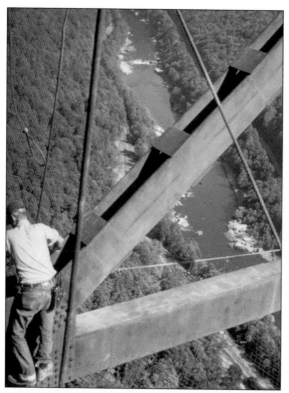

The New River Gorge Bridge was constructed of unpainted Cor-Ten steel. This alloy contains special properties allowing it to corrode and form its own weather-proof coating, giving the steel a rusty weathered veneer. Using Cor-Ten saved $300,000 on the original cost of the bridge. Each additional painting would have cost approximately $1 million. (Photograph by David Bowen, courtesy WVDOH.)

The New River Gorge Bridge is a key component of the Appalachian Corridor System. Although initial traffic on the New River Gorge Bridge was light, 16,000 cars crossed the bridge daily by 2006. (Photograph by David Bowen, courtesy WVDOH.)

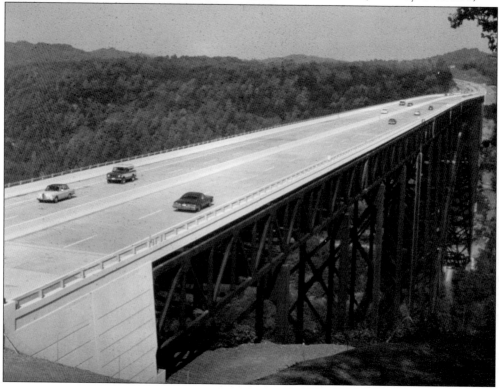

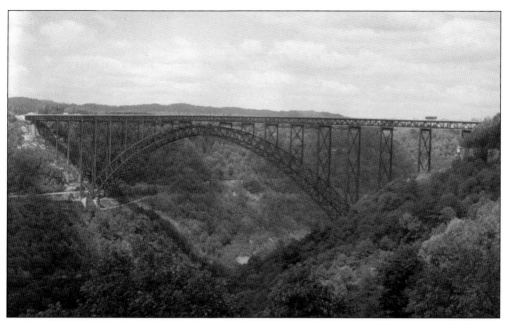

Constructed by the American Bridge Division of United States Steel, the New River Gorge Bridge cost nearly $37 million. At 876 feet above the New River, it is 325 feet higher than the Washington Monument. This height makes the bridge an excellent location for BASE jumping, only legal on Bridge Day, always held the third Saturday of October. (Photograph by David Bowen, courtesy WVDOH.)

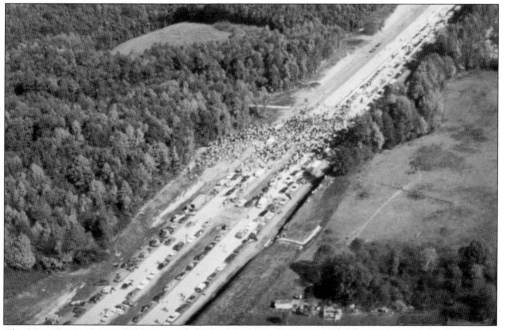

The New River Gorge Bridge was dedicated on October 22, 1977. The success of the dedication and the desire of people to visit and see the bridge led to Bridge Day being established in 1979. On that day, the bridge is closed to vehicular traffic and BASE jumping is legal. Up to 300,000 people attend West Virginia's largest one-day event. (Photograph by David Bowen, courtesy WVDOH.)

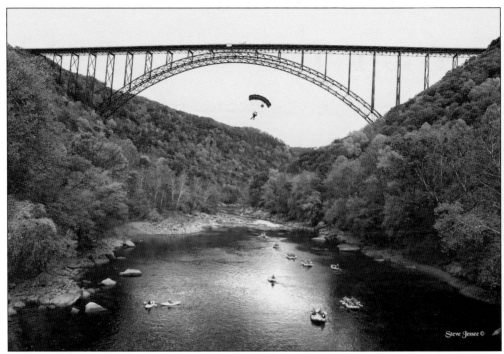

Each year, up to 450 people register to jump legally on Bridge Day, and many make multiple leaps. Bystanders line the bridge rail to watch up to 800 jumps as successful jumpers ride to the top of the gorge. The landing zone is a small beach above Fayette Station Rapid on "river left." Underneath the bridge, teams rappel from ropes secured to the bridge's catwalk. (Photograph by Steve Jessee, courtesy New River Convention and Visitors Bureau.)

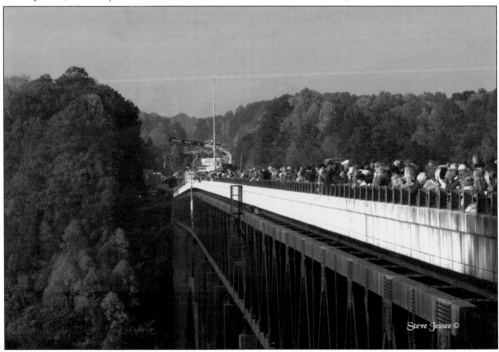

FAYETTE COUNTY

CHAMBER OF COMMERCE

WEST VIRGINIA

Make the most of your visits to the New River Gorge. From Gauley Bridge to Glen Jean, our region offers an inviting mix of things to do and places to go and, everywhere, great people to meet. You'll find yourself making great memories and friends you want to see again and again. While you are in the area, make sure to hit the town of Ansted. Here you can ride *Miss M. Rocks* from the Hawks Nest marina to see the New River Gorge Bridge, towering 876 feet above you. While in Ansted, stop at the new Chimney Corner Country Store, Mystery Hole, or Blue Smoke Salsa for a tour. If history is your thing, make sure and visit the Historic Train Station at Thurmond or the historic town of Mount Hope and Fayetteville. There are several heritage festivals that will give you a new appreciation for our home and our lifestyle. Just looking for a little peace and quiet? You can find it in the New River Gorge with beautiful scenery and hiking trails. Take a day and follow a meandering trail in search of waterfalls and scenic overlooks. Our visitor center is conveniently located at the Oyler Avenue Exit off Route 19 in Oak Hill. Stop by when you are in the area and we will be glad to help you with all your relocation and vacation information. For more information on New River Gorge call 800-927-0263 or visit www.newrivergorgecvb.com.

www.arcadiapublishing.com

MAP SEARCH

Discover books about the town where you grew up, the cities where your friends and families live, the town where your parents met, or even that retirement spot you've been dreaming about. Our Web site provides history lovers with exclusive deals, advanced notification about new titles, e-mail alerts of author events, and much more.

MADE IN THE
USA

Arcadia Publishing, the leading local history publisher in the United States, is committed to making history accessible and meaningful through publishing books that celebrate and preserve the heritage of America's people and places. Consistent with our mission to preserve history on a local level, this book was printed in South Carolina on American-made paper and manufactured entirely in the United States.

This book carries the accredited Forest Stewardship Council (FSC) label and is printed on 100 percent FSC-certified paper. Products carrying the FSC label are independently certified to assure consumers that they come from forests that are managed to meet the social, economic, and ecological needs of present and future generations.

FSC
Mixed Sources
Product group from well-managed forests and other controlled sources

Cert no. SW-COC-001530
www.fsc.org
© 1996 Forest Stewardship Council

Find Your Place in History.